Time can pass very quickly and sometimes we forget to pause for a moment and appreciate those around us.

The year 2000 will mark the 50th anniversary of our company but 1998 marks 5 years since I took the reigns from Charlie McKenna, my father.

I attribute the success of the company to the enthusiastic contributions of the staff, our suppliers, and because of the loyalty of our clients.

Thanks.

John McKenna

CANADA'S
NATIONAL
PARKS

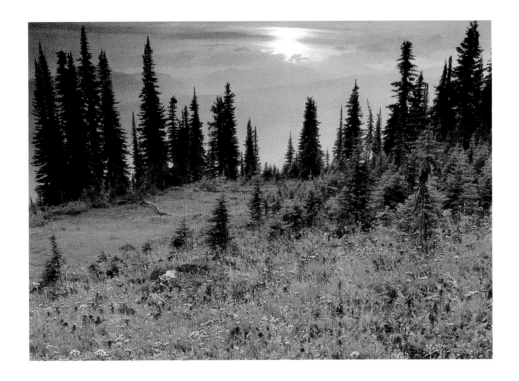

WHITECAP BOOKS
VANCOUVER/TORONTO

Cover and book design by Steve Penner
Cover photograph by Darwin Wiggett / First Light
Text by Tanya Lloyd
Edited by Elaine Jones
Proofread by Lisa Collins
Photo editing by Pat Crowe

Printed and bound in Canada by Friesens, Altona, Manitoba.

Canadian Cataloguing in Publication Data
Lloyd, Tanya, 1973-
 Canada's national parks

ISBN 1-55110-525-X

 1. National parks and reserves--Canada--Pictorial works. I. Title. II. Series:
Lloyd, Tanya, 1973-
FC215.L66 1997 971.06'8'0222 C96-910738-4
F1011.L66 1997

The publisher acknowledges the support of the Canada Council and the
Cultural Services Branch of the Government of British Columbia in making
this publication possible.

**For more information on this series and other Whitecap
Books titles, visit our web site at www.whitecap.ca.**

When a nineteenth-century railway worker saw the Cave and Basin Hot Springs in what is now Banff National Park, he called it "some fantastic dream from a tale of the Arabian nights." Like many of the first Europeans to reach Canada's Rocky Mountains, William McCardell was enthralled by the rugged peaks, emerald blue lakes, and treacherous glaciers. As the Canadian Pacific Railway brought more and more people across the continent, the southern Rockies captured the imaginations of tourists, businessmen, and adventurers.

The Canadian government declared the area a national reserve in 1885, beginning a system of parks that now stretches from the Bay of Fundy to the western edge of Vancouver Island. Canada boasts the most extensive national park network in the world. In each park, visitors discover one of the country's vastly different land or marine regions.

Each fall at Point Pelee National Park, the trees and undergrowth are carpeted in a fluttering mass of orange wings, as thousands of monarch butterflies migrate southward. They rest at Canada's southernmost point of land, an area at the latitude of northern California. At the same time, far within the Arctic Circle, hundreds of polar bears head onto the ice around Ellesmere Island National Park, where they will spend the winter hunting seals.

Along with a startling variety of wildlife, visitors to Canada's national parks will find towering waterfalls, alpine meadows, and cliffs carved by the last ice age. In British Columbia's Yoho National Park, the Burgess Shale holds the fossils of sea creatures from 350 million years ago. Across the country in Newfoundland's Gros Morne National Park, hikers can paddle into the fiords, gazing up more than 700 metres to the ancient ridges.

Revealing the best of Canada's natural beauty, these national parks draw thousands of visitors each year. Some, such as Banff National Park, attract so many tourists that the government must constantly struggle to balance the needs of wildlife with those of human beings. Others, such as the Yukon's Kluane National Park, continue to draw only the most hardy adventurers, seeking a look at some of the world's unique places.

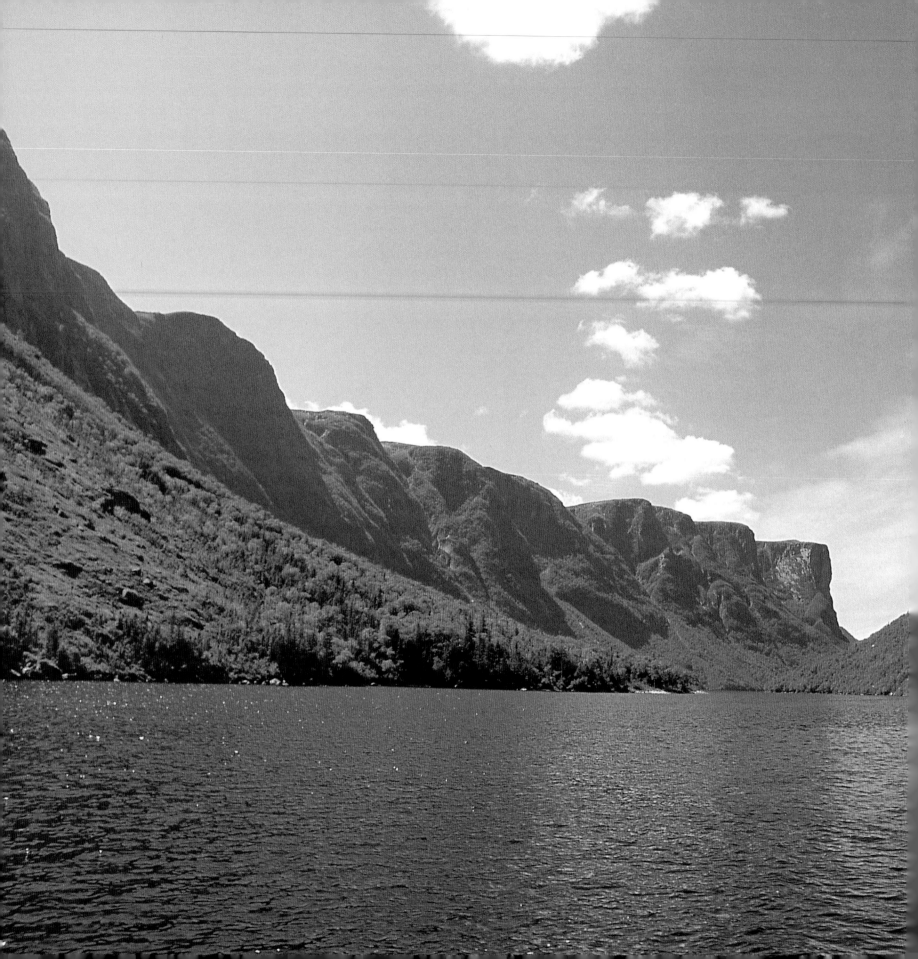

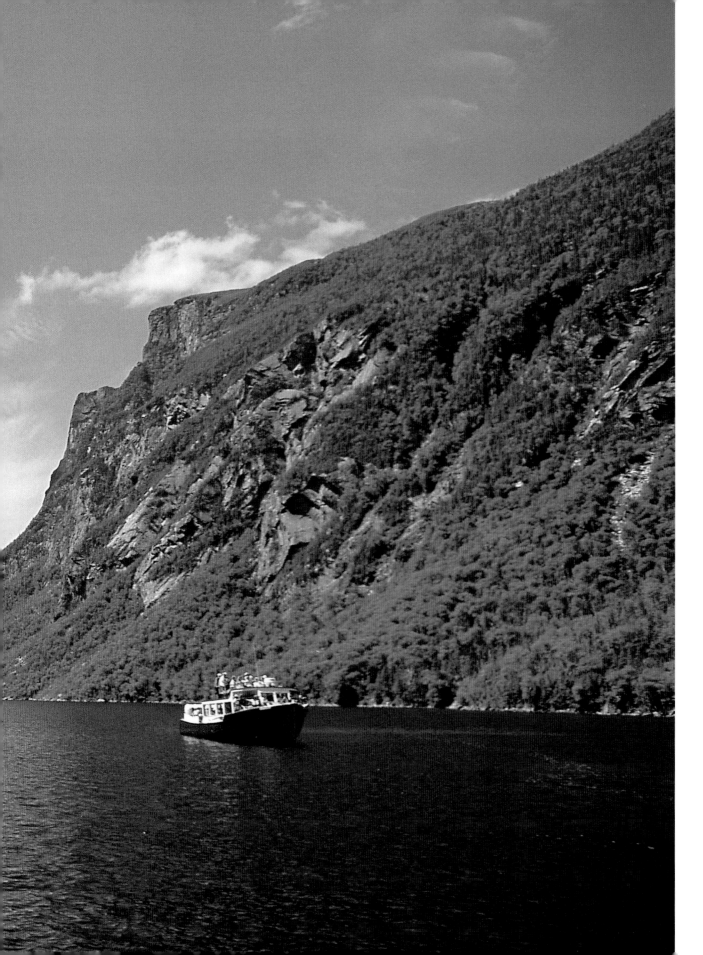

Newfoundland's Western Brook Pond is just one of the spectacular fiords in Gros Morne National Park. Cliffs drop 700 metres to the water. Once molten rock far beneath the earth's surface, this stone became part of the crust 400,000 years ago.

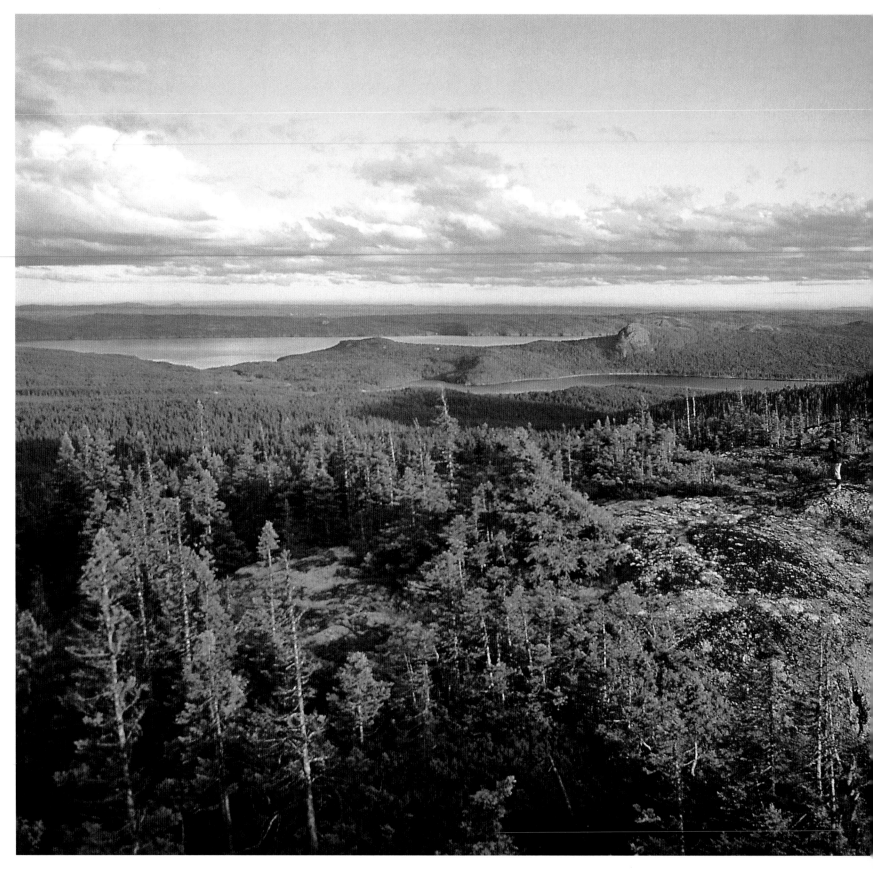

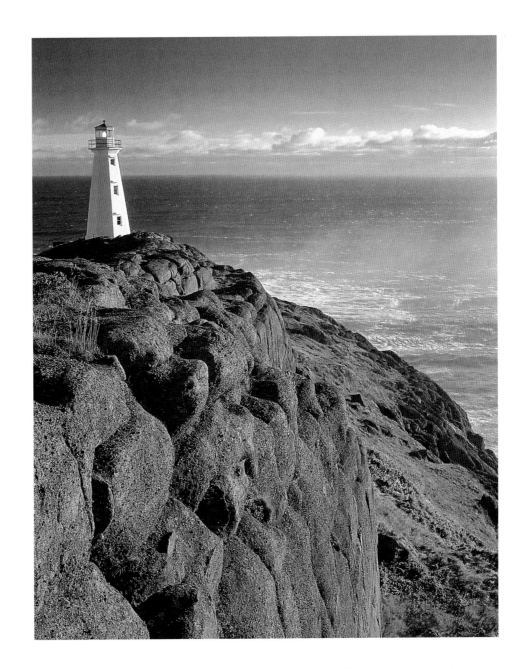

Canada's oldest lighthouse stands 75 metres above the Atlantic on Cape Spear, Newfoundland, North America's eastern tip. The beacon was built in 1836 and used until 1955. The lighthouse keeper's quarters have now been restored as part of this national historic site.

Terra Nova National Park was established in 1957, just ten years after Newfoundland joined Confederation. Hikers who scale the slopes of the ancient Appalachian Mountain Range to Blue Hill Lookout gain a breathtaking view of the Atlantic.

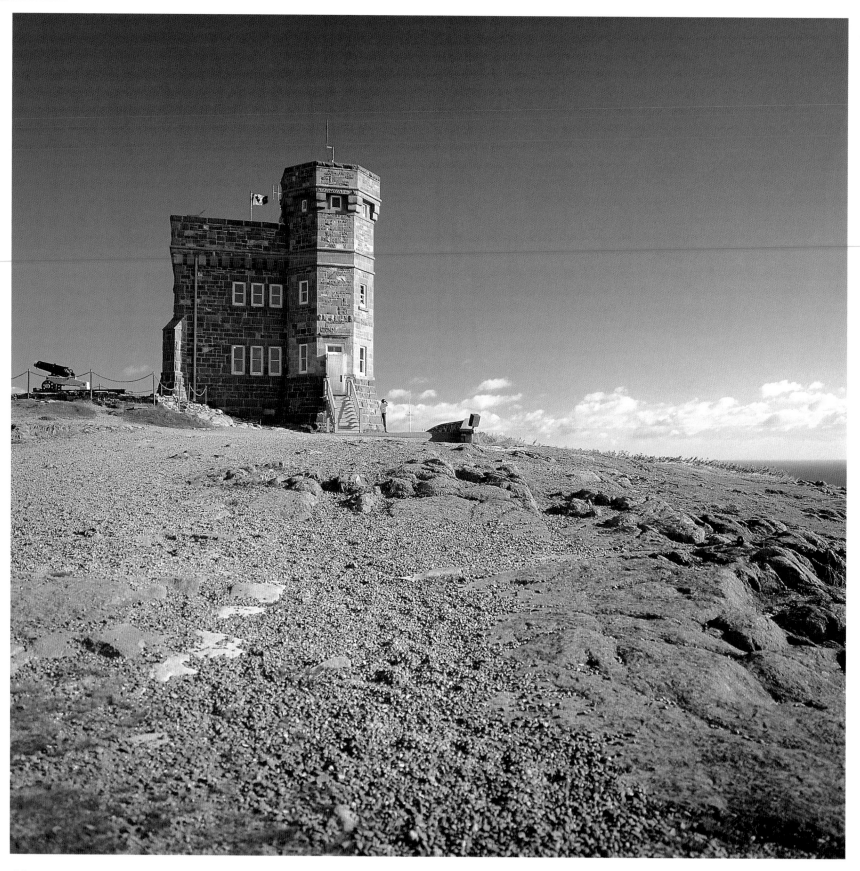

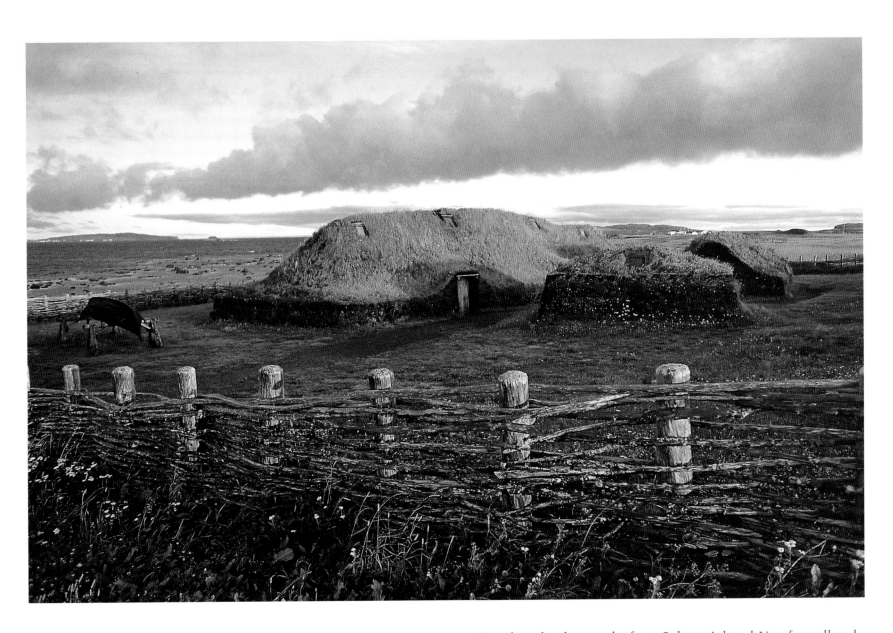

In 1901, the world's first radio transmission was sent from Cornwall, England. Italian inventor Guglielmo Marconi received the message in Morse code at Signal Hill, St. John's, Newfoundland, now a national historic site.

Five hundred years before Cabot sighted Newfoundland, Norse sailors and explorers founded a village at what is now designated L'Anse aux Meadows National Historic Site. Archaeologists have uncovered remains from A.D. 1000 and visitors to the UNESCO World Heritage Site can wander through sod buildings and view artifacts and models of the settlement.

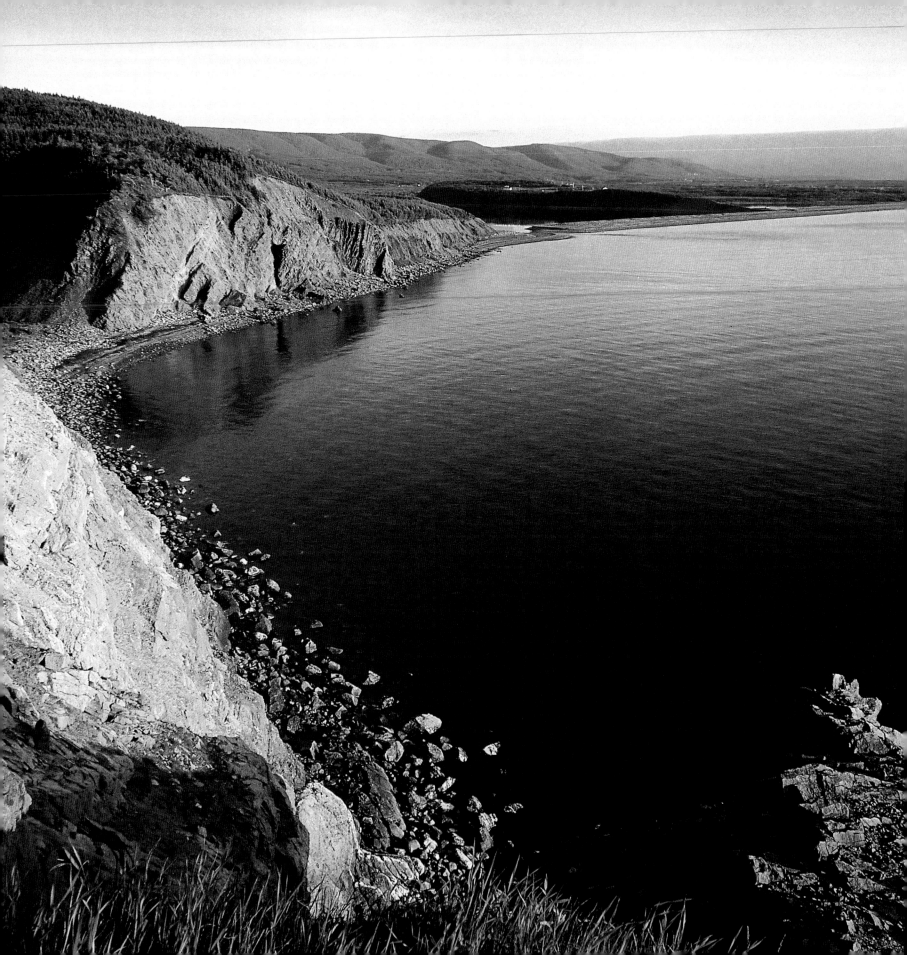

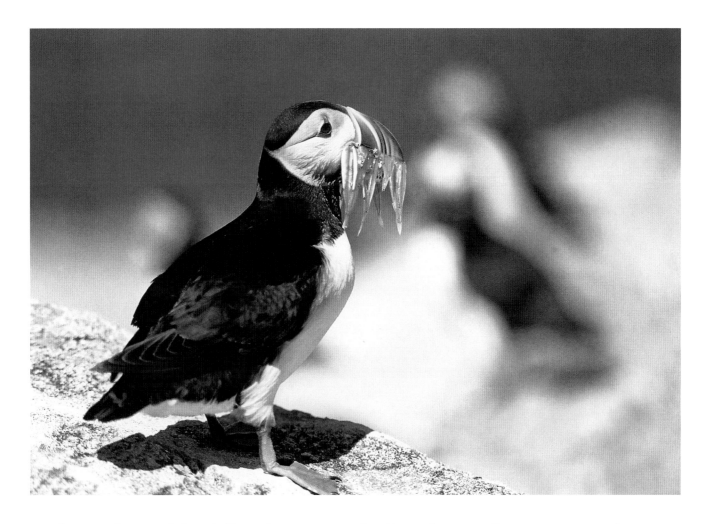

Pinchers at the tip of their bills and grooves inside allow Atlantic puffins to capture and carry up to 30 small fish at once. Puffin chicks eat their body weight in fish each day—it's no wonder these birds have only one chick per year.

The rugged scenery of Nova Scotia's Cape Breton Highlands National Park can be seen from one of 30 hiking trails or glimpsed from the 294-kilometre-long Cabot Trail, one of Canada's most dramatic highways. Most of the park is a high boreal plateau, home to lynx, deer, bears, and more than 200 bird species.

In Cape Breton Highlands National Park, Mary Ann Falls pours over granite boulders left by the last ice age. Thirty hiking trails crisscross the park, winding through groves of yellow birch, beech, and sugar maples.

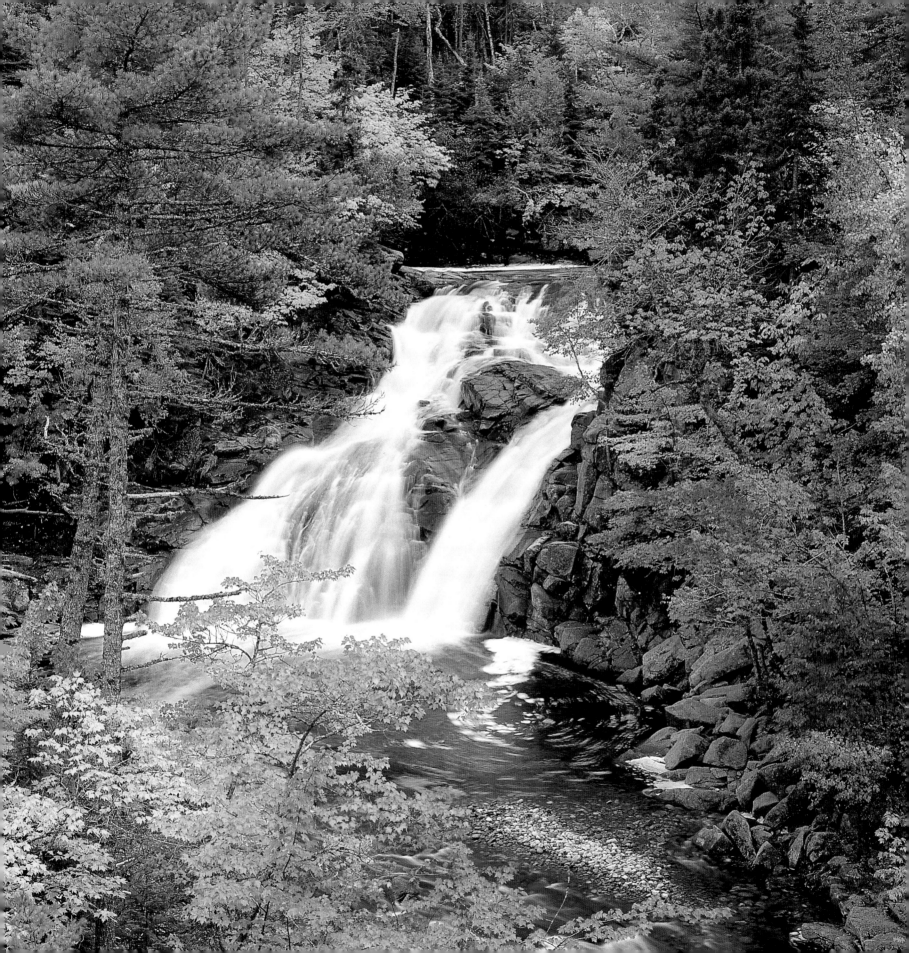

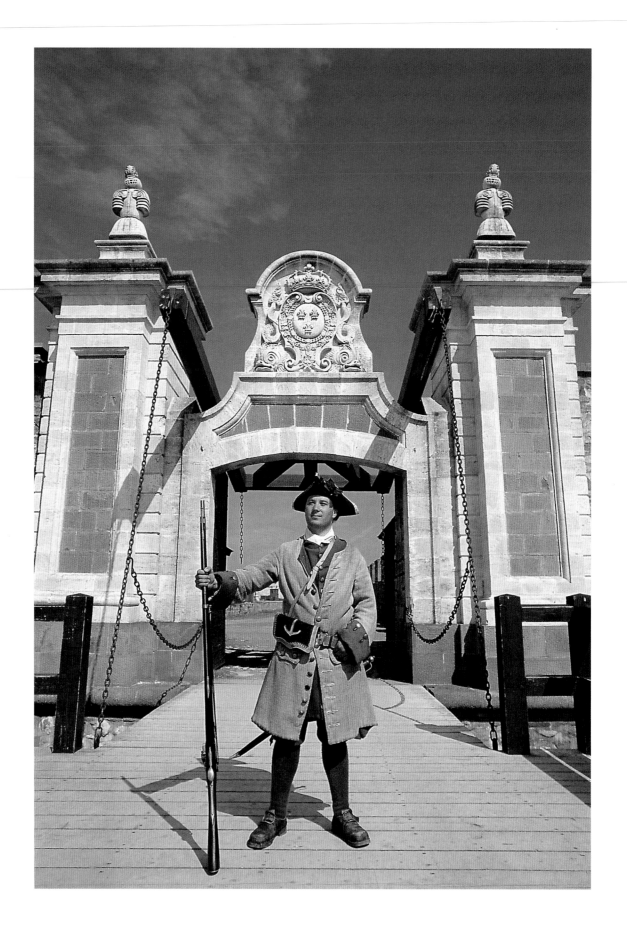

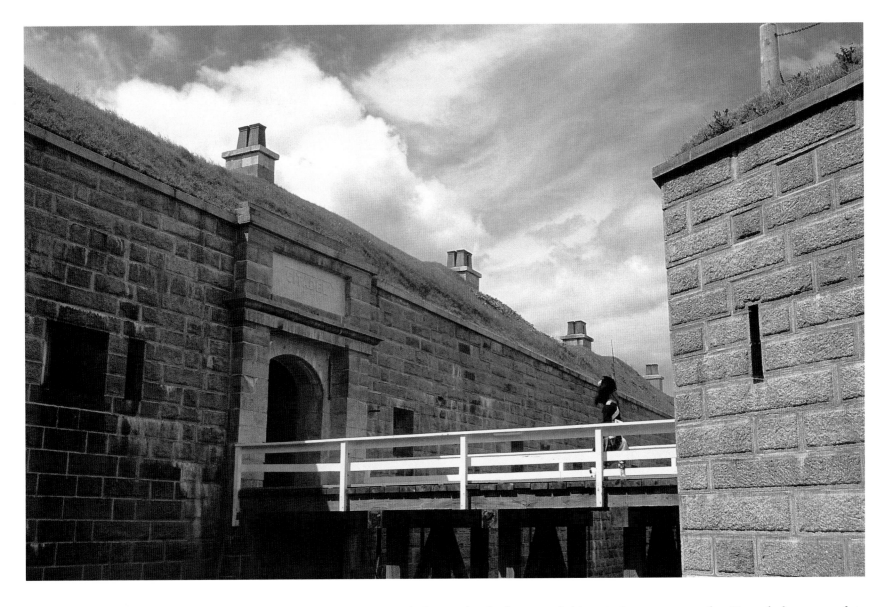

British forces built the Citadel in 1749 to counter the French fortress of Louisbourg. The star-shaped structure was the stronghold of Halifax's fortifications and the beginning of the area's long military history. Today, navy ships still share the harbour with freighters and pleasure boats.

Built by the French, captured by the New Englanders, and destroyed by the British, the Fortress of Louisbourg on Cape Breton Island played a pivotal role in Canadian history. Its destruction in 1760 signalled the end of France's hold on the colony. The fortress has been rebuilt and designated a national historic site.

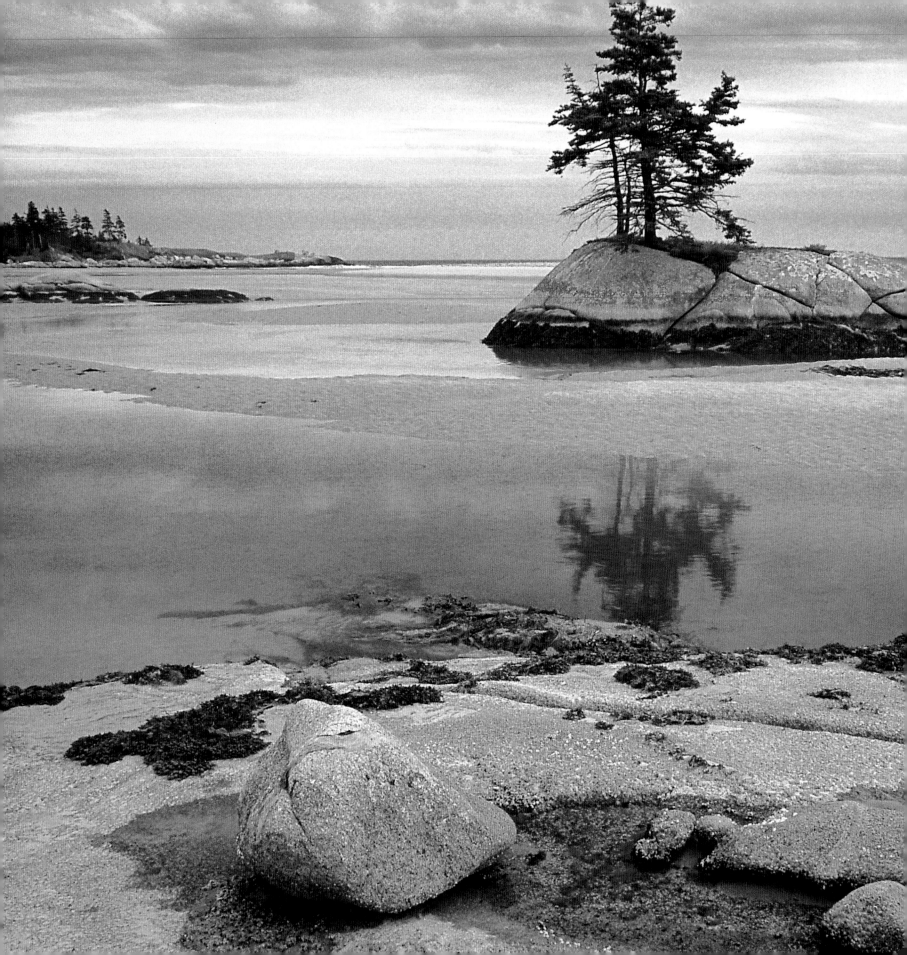

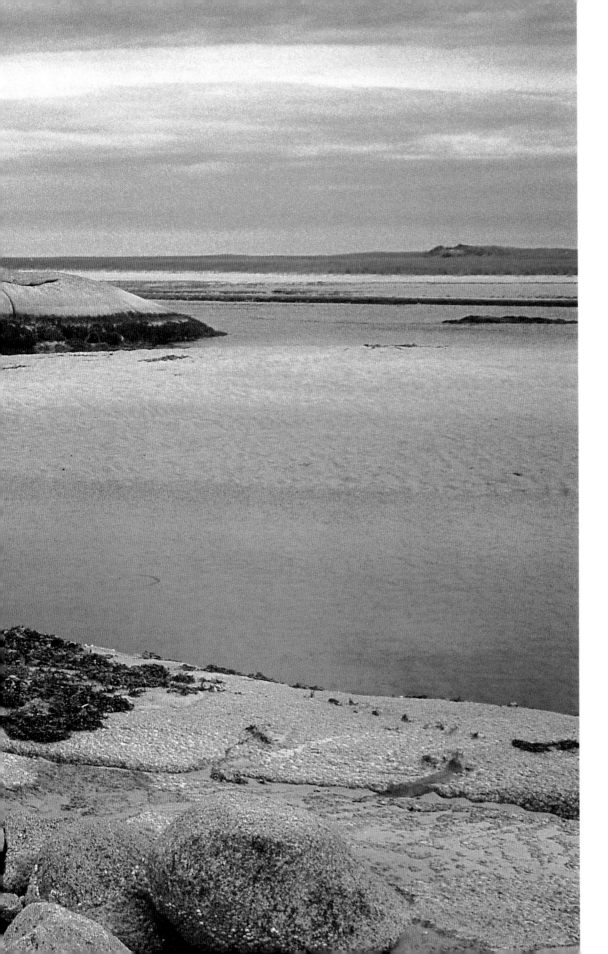

The 22-square-kilometre Seaside Adjunct to Kejimkujik National Park protects one of the last undeveloped stretches of Nova Scotia's coast. The shoreline ranges from rocky outcroppings to long, sandy beaches.

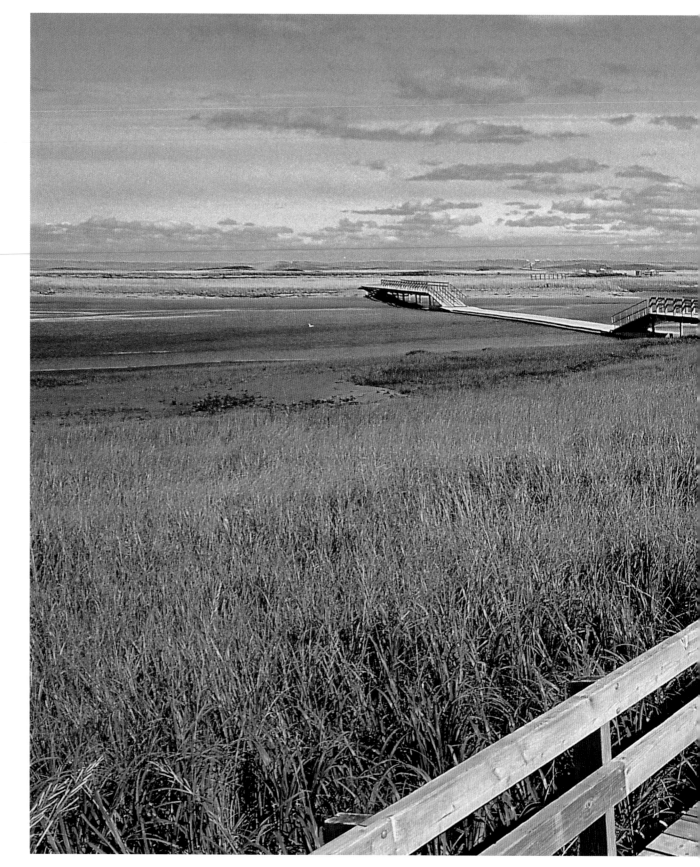

A boardwalk helps protect the delicate balance between wildlife and visitors at New Brunswick's Kouchibouguac National Park. The region's lagoons, sand dunes, and saltwater marshes are important nesting grounds for the endangered piping plover and the park's symbol, the osprey. *Kouchibouguac* is a Micmac word meaning "river of the long tides."

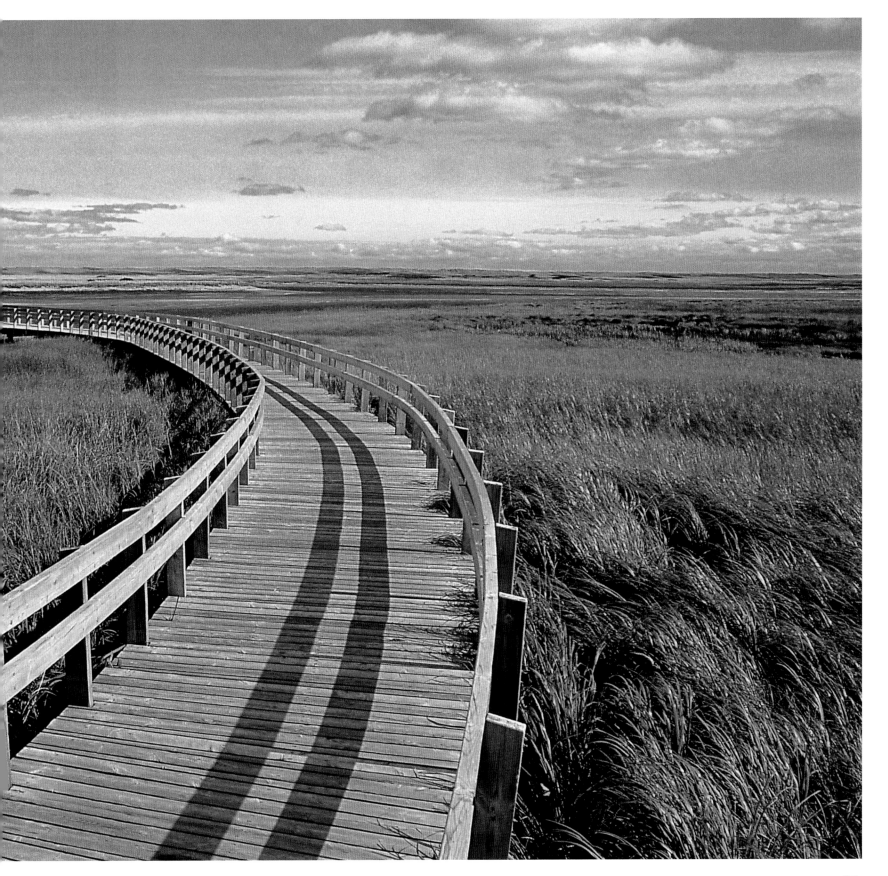

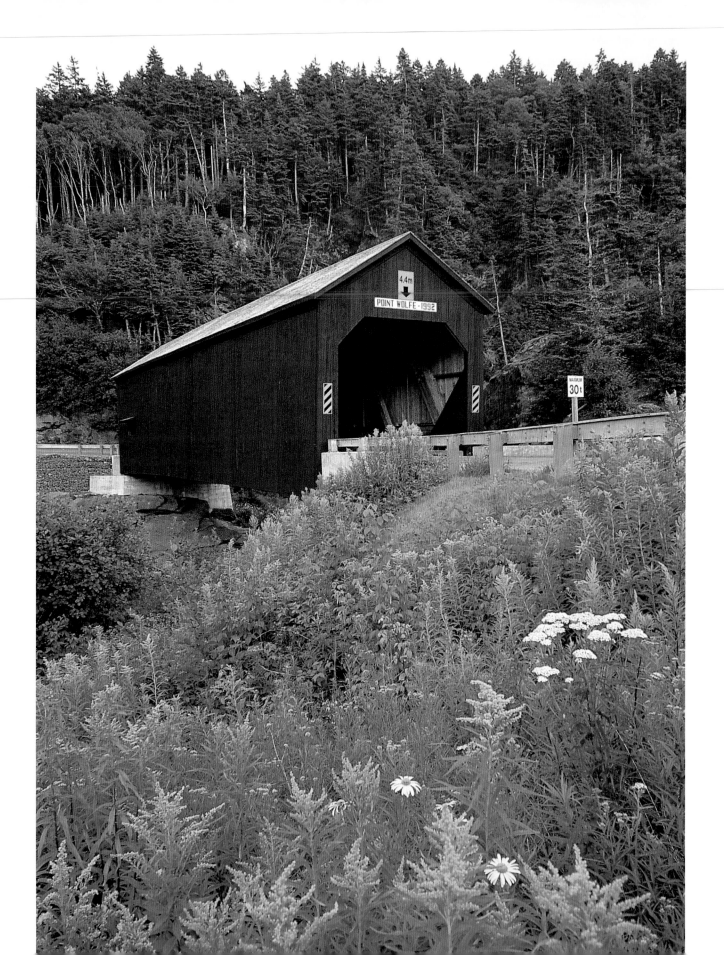

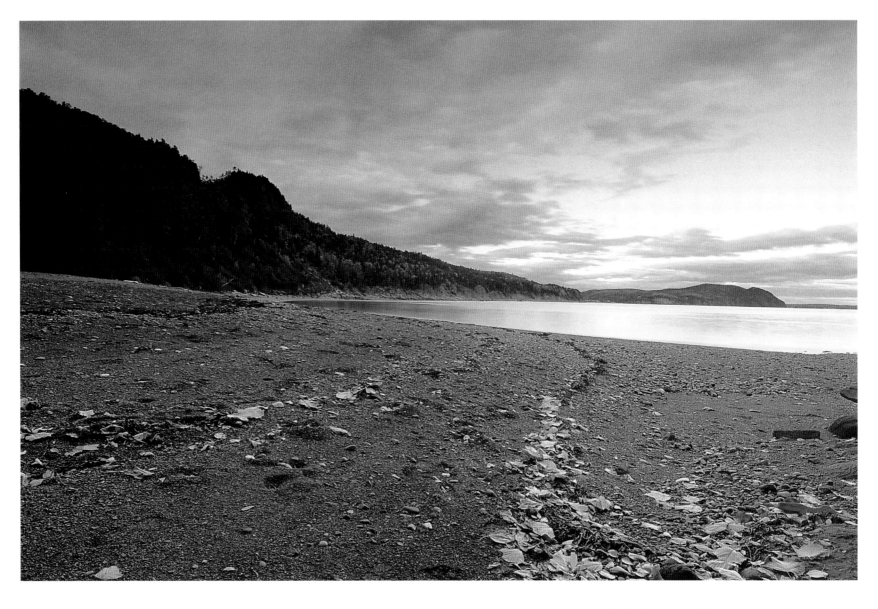

The world's highest tides—averaging eight metres and sometimes reaching more than fifteen—sweep through the Bay of Fundy, New Brunswick.

Pointe Wolfe bridge is one of two covered bridges in Fundy National Park, New Brunswick. This is actually a reconstruction— a work crew accidently blasted the old bridge in 1990.

OVERLEAF –
Prince Edward Island National Park protects about 40 kilometres of cliffs and beaches along the Gulf of St. Lawrence. The waters lure crowds of summer swimmers, while skiers and snowshoers enjoy the park in winter.

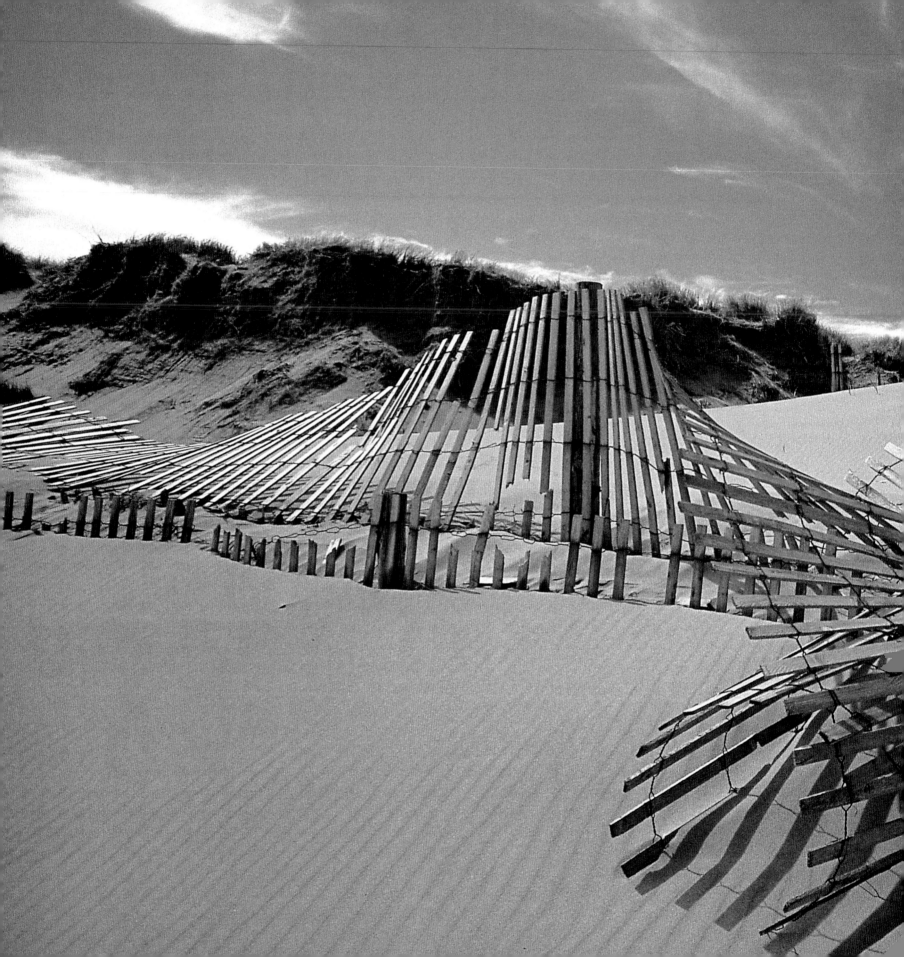

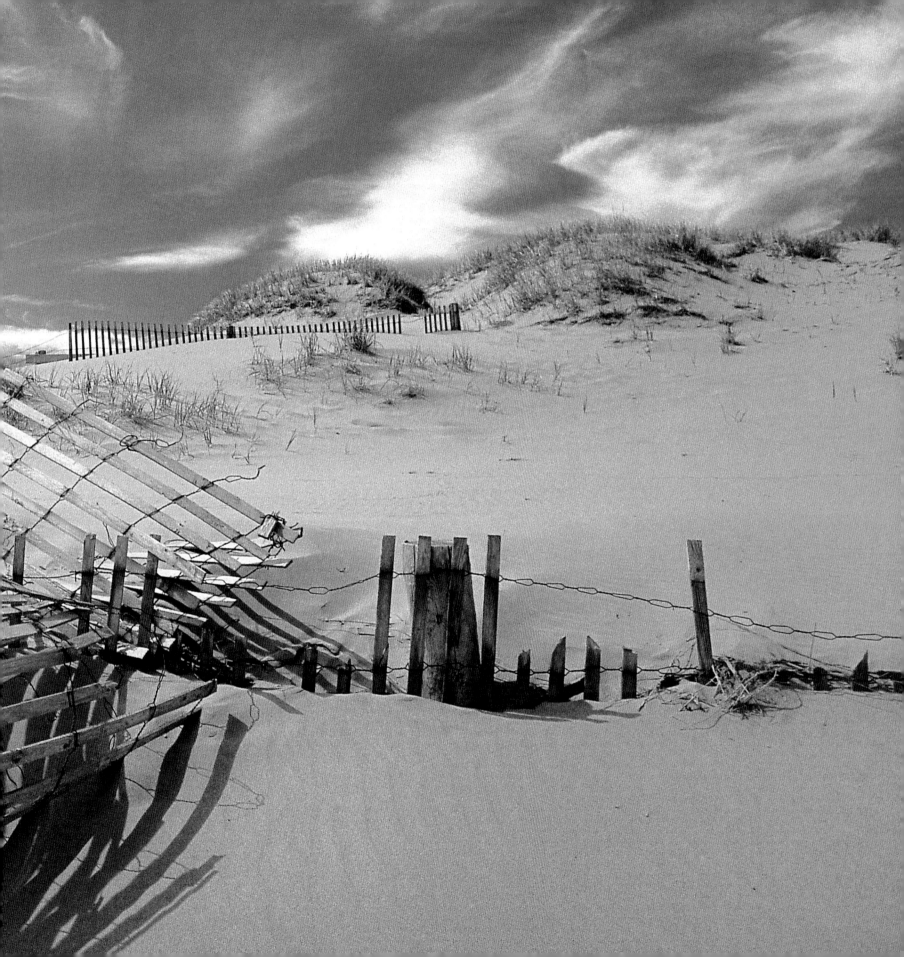

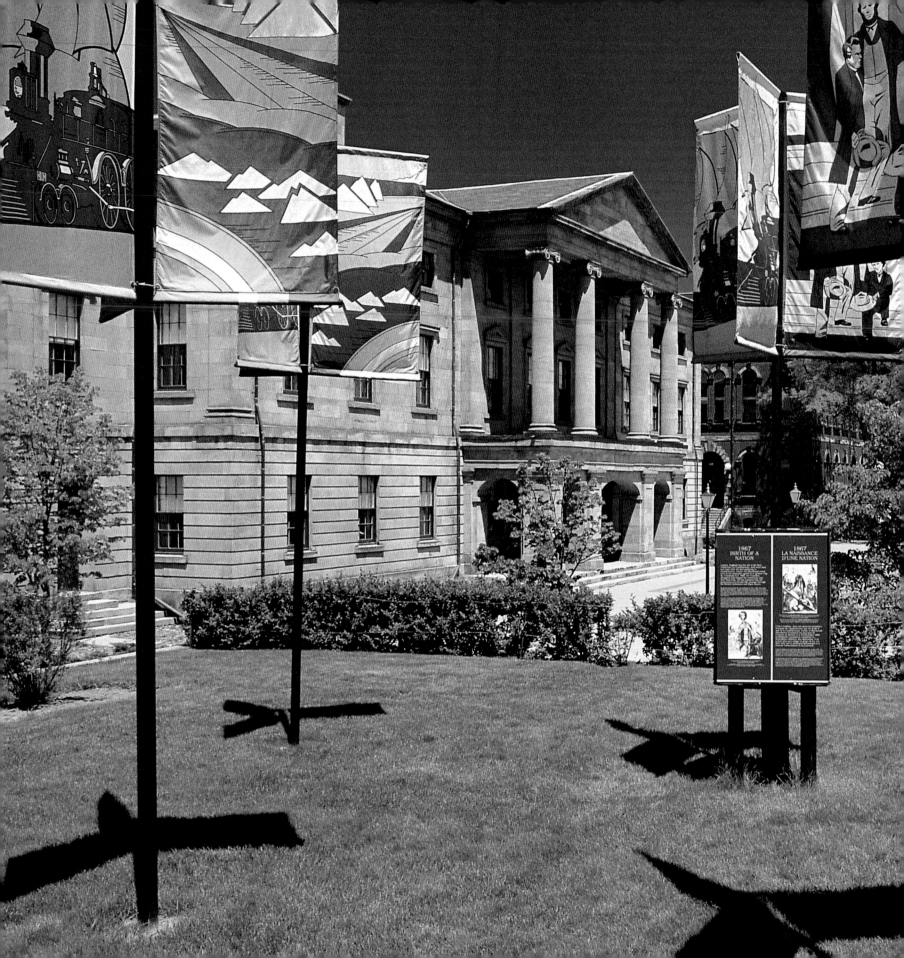

Prince Edward Island's provincial legislature, known as Province House, was opened in 1847. This national historic site is the birthplace of Confederation, where the leaders of nineteenth-century Nova Scotia, New Brunswick, Ontario, Quebec, and Prince Edward Island met in 1864 to discuss a possible union.

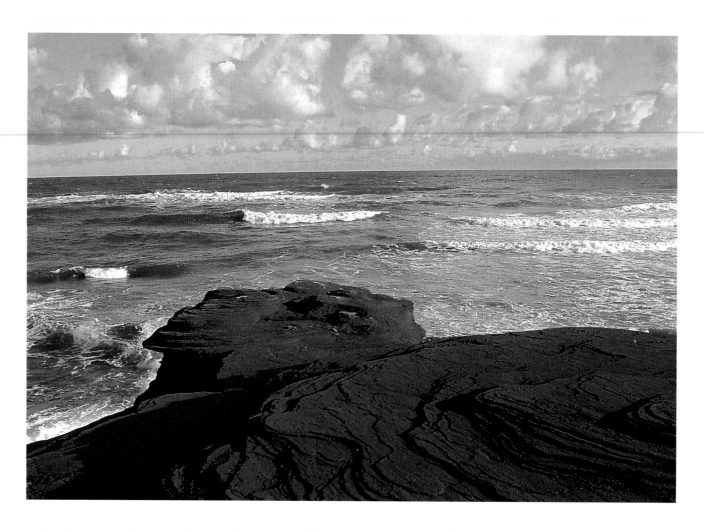

Atlantic swells have sculpted the west end of Prince Edward Island National Park to create jagged red sandstone cliffs and arresting rock formations.

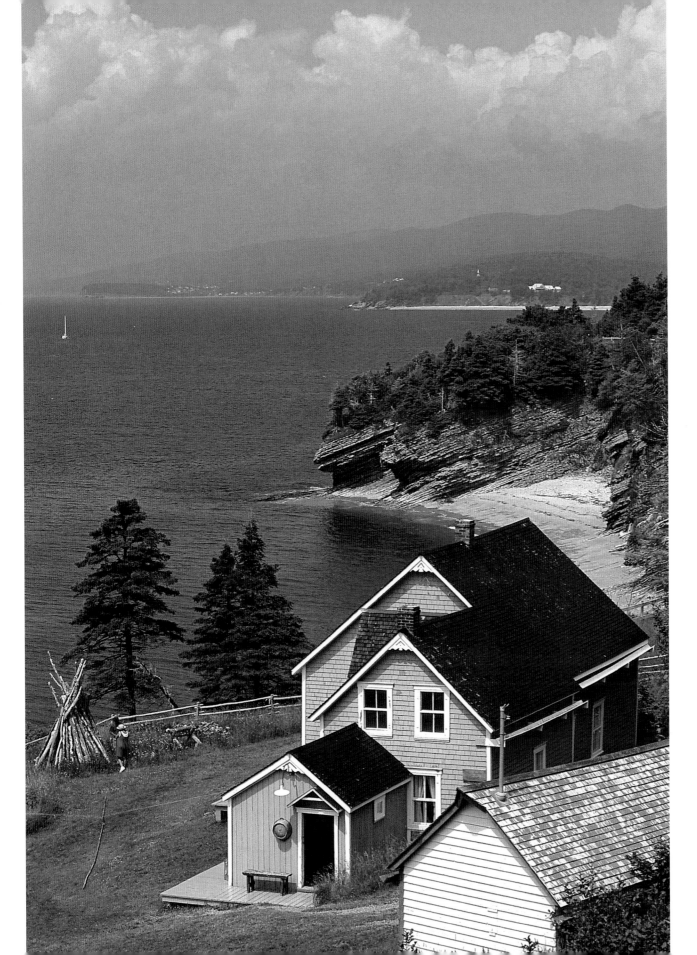

The interpretive theme at Quebec's Forillon National Park is "Harmony between Man, Land and Sea." First Nations peoples used this area as a fishing base for thousands of years, and French farmers and fishers lived here until the park's development in 1974.

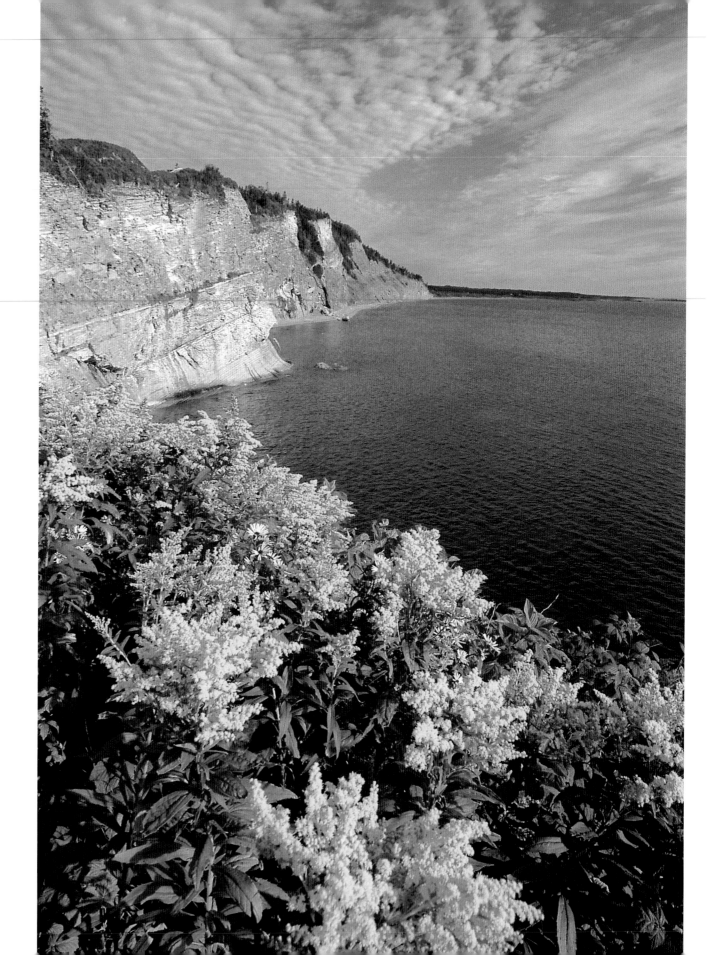

On the eastern tip of Quebec's Gaspé Peninsula, south of the St. Lawrence River, the limestone cliffs of Cap-Bon-Ami form part of Forillon National Park.

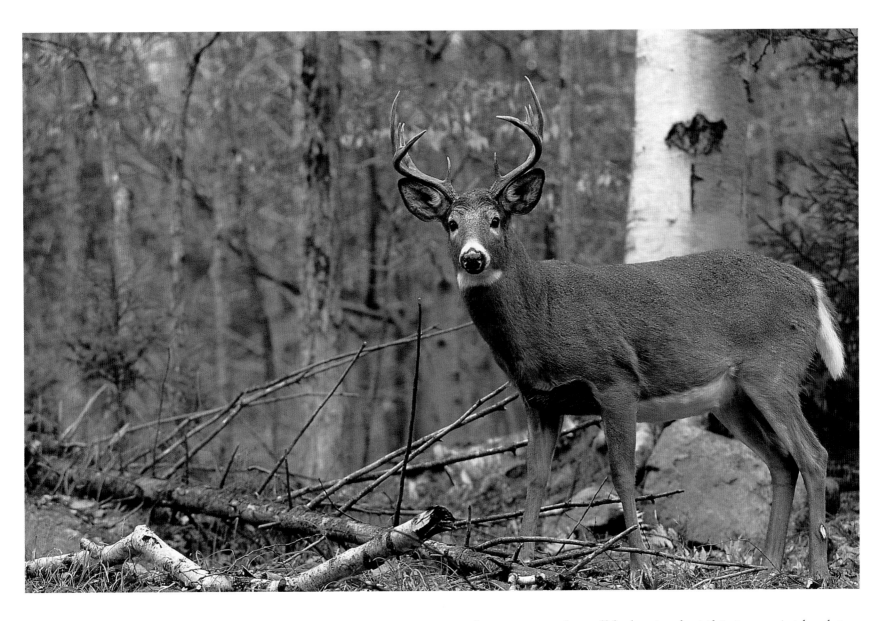

A keen sense of smell helps to alert this ten-point buck to predators. If startled, it can flee at up to fifty kilometres an hour through the trees.

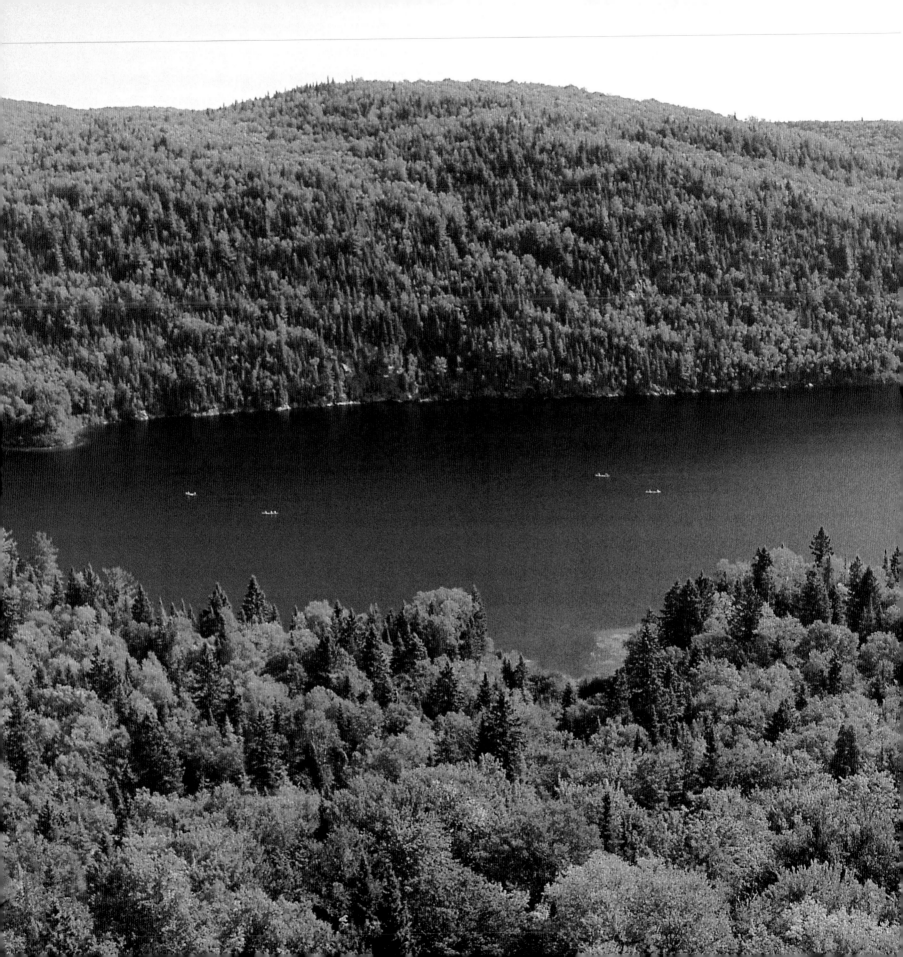

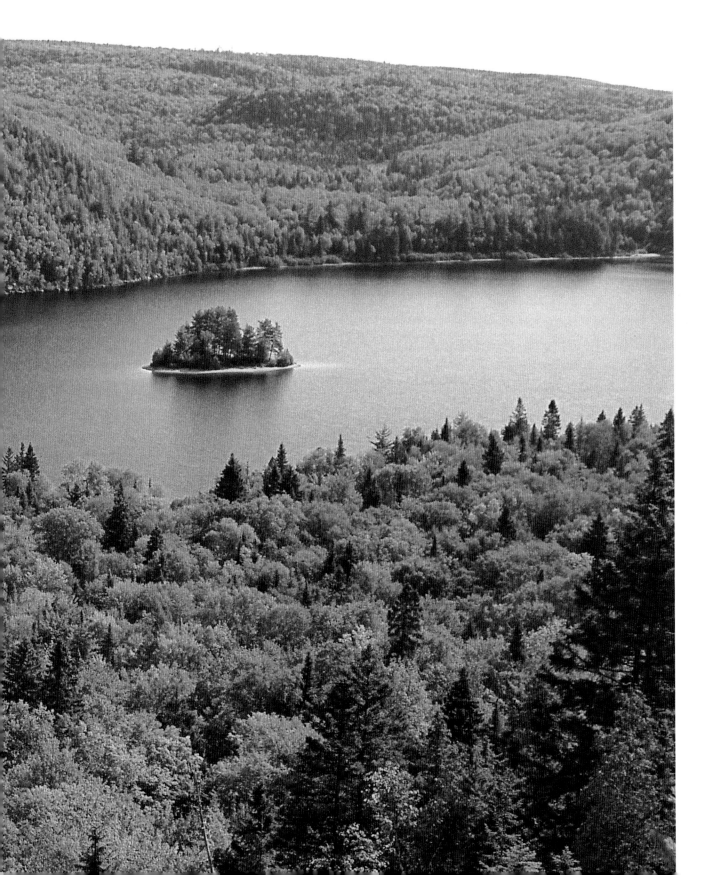

The lakes in Quebec's largest national preserve, La Mauricie National Park, were carved by the glaciers of the last ice age. The area has attracted visitors since nomadic tribes fished here 2000 years ago.

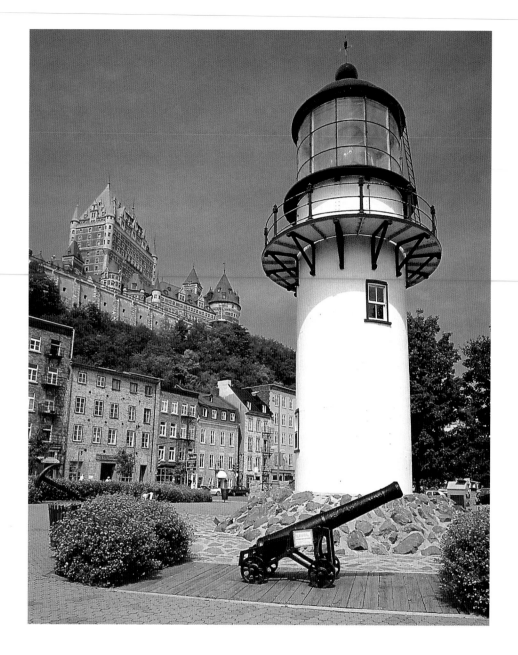

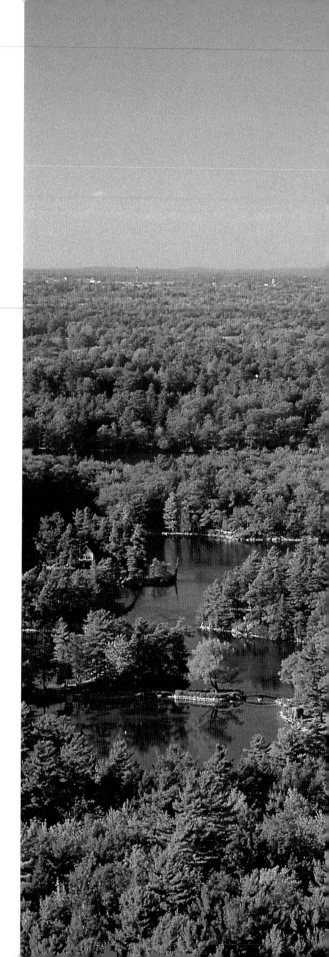

In 1985, UNESCO named Quebec City the continent's first world heritage site. The oldest quarter, the *Haute-Ville*, is the only walled city remaining in North America. Many of the stone buildings were built in the seventeenth and eighteenth centuries.

More than 1800 islands dot the St. Lawrence River between Canada and the United States, some only a few metres across and others large enough for a dock and waterfront home. St. Lawrence Islands National Park in Ontario is Canada's smallest national preserve, protecting nine square kilometres.

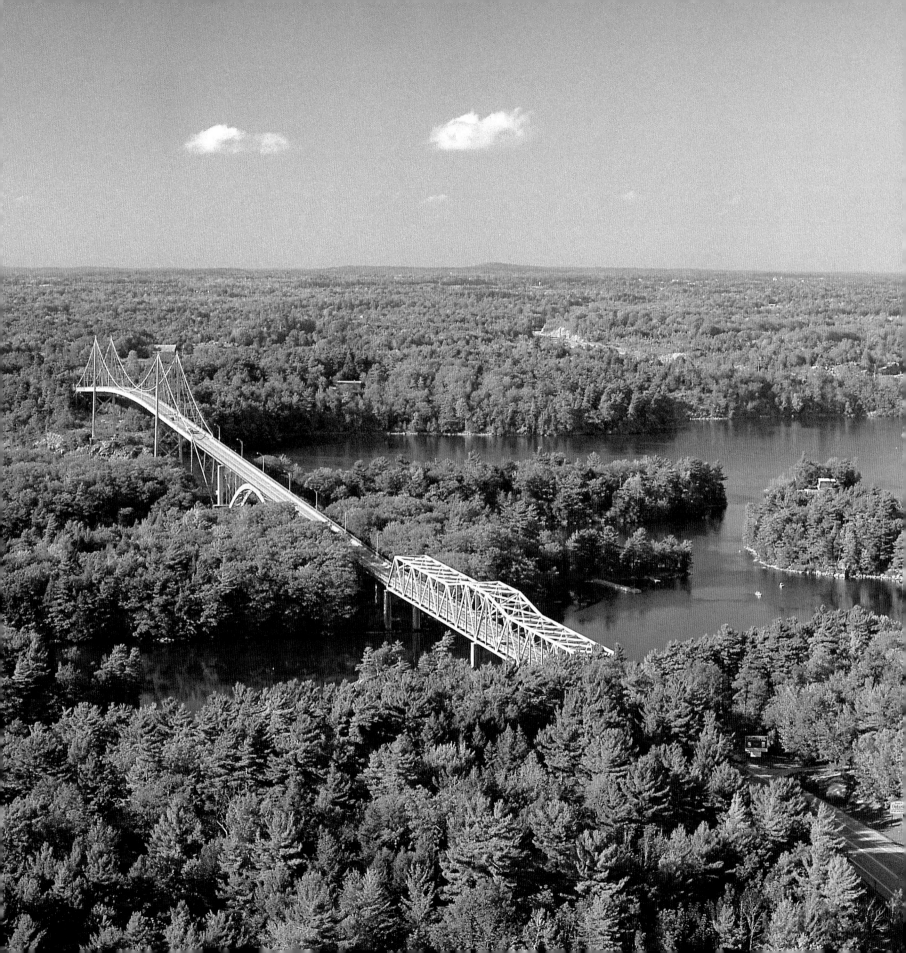

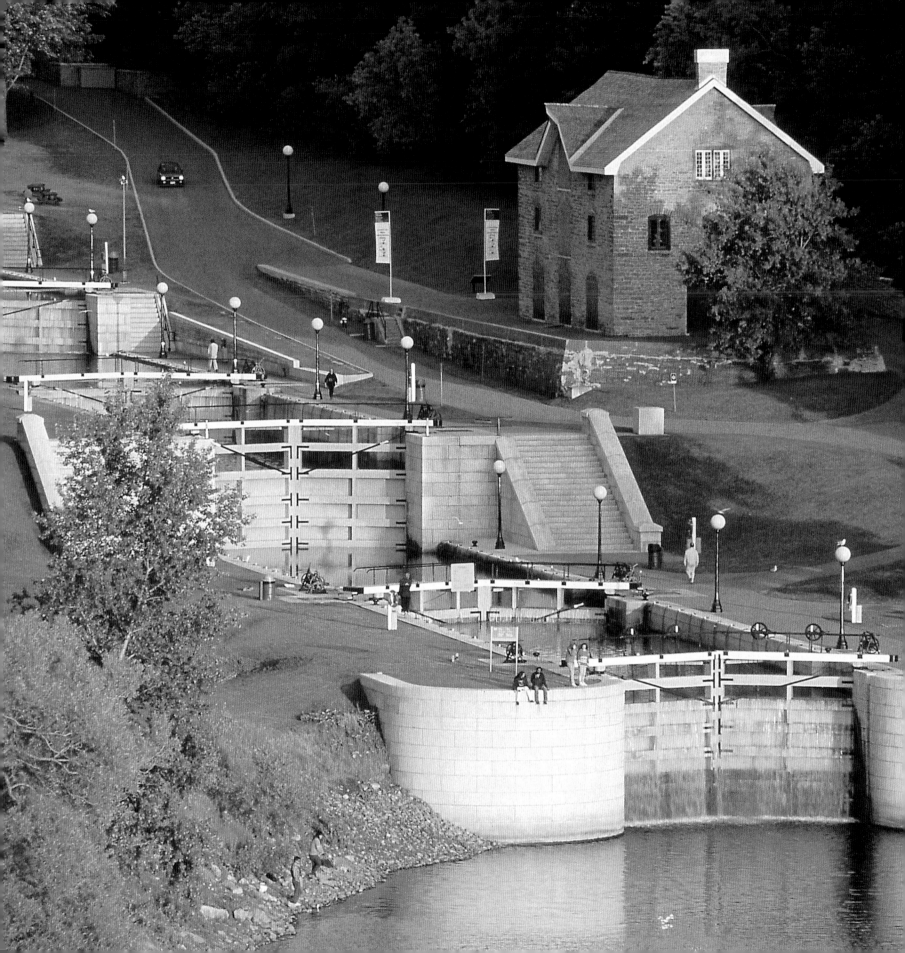

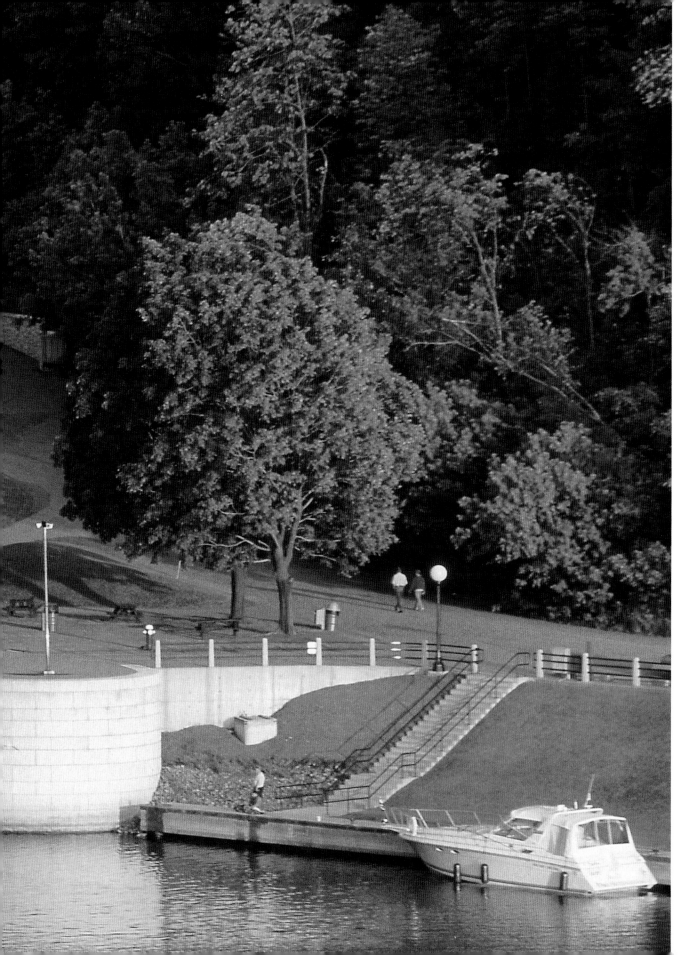

The eight hand-operated locks of the Rideau Canal connect it to the Ottawa River. They were opened for commercial use in 1832 and are now protected as a national historic site.

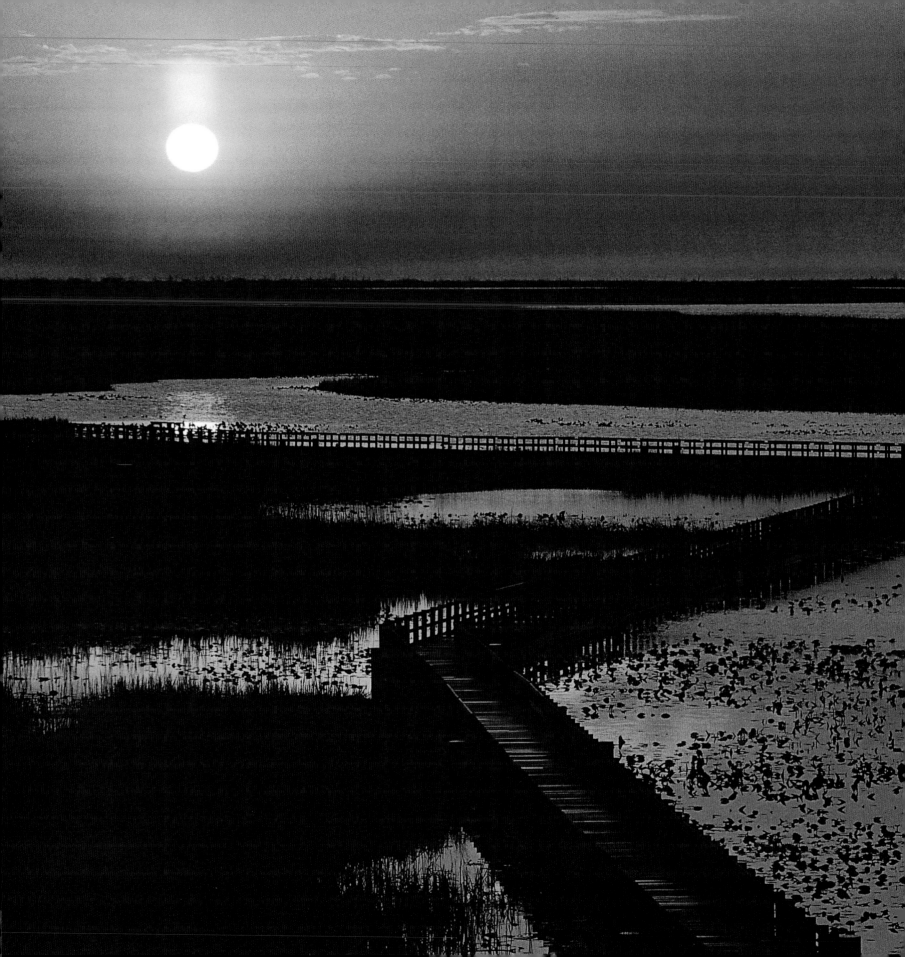

Filled with displays on the region's military past and the history of Kingston's Royal Military College, this Martello tower is one of the college's most interesting structures.

Canada's southernmost tip, Point Pelee, Ontario, is at the same latitude as northern California. Thousands of birds stop here on their annual migrations, and they are joined each fall by flights of monarch butterflies.

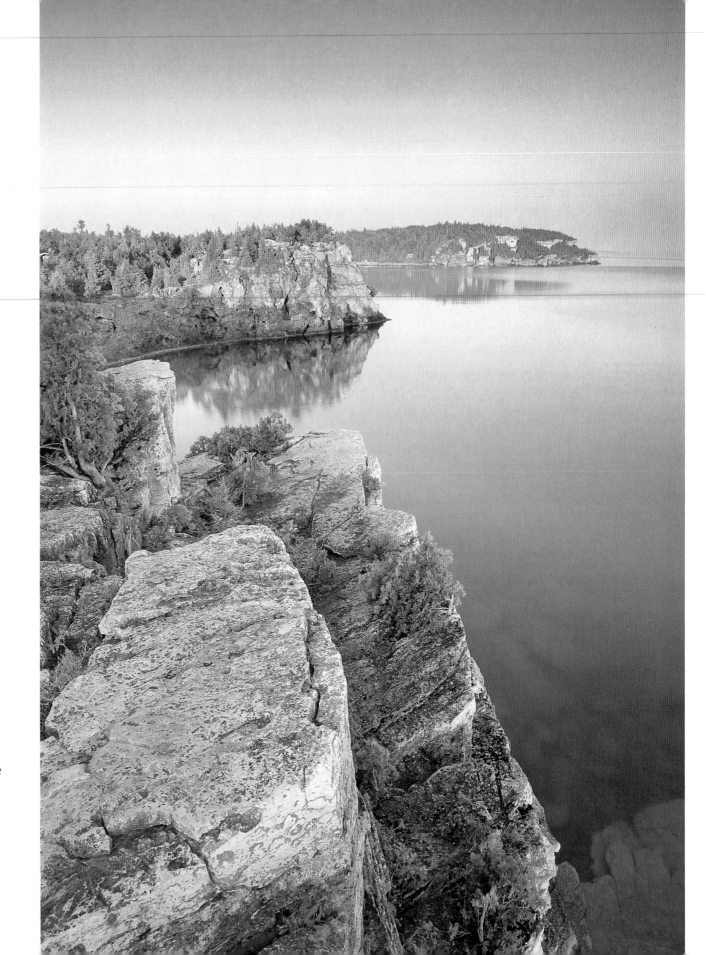

Rugged cliffs drop to Lake Huron from Bruce Peninsula National Park. Views like this one have drawn thousands of hikers to the Bruce Trail, a challenging 720-kilometre route from Tobermory, a community within the park, to Queenston, near Niagara Falls.

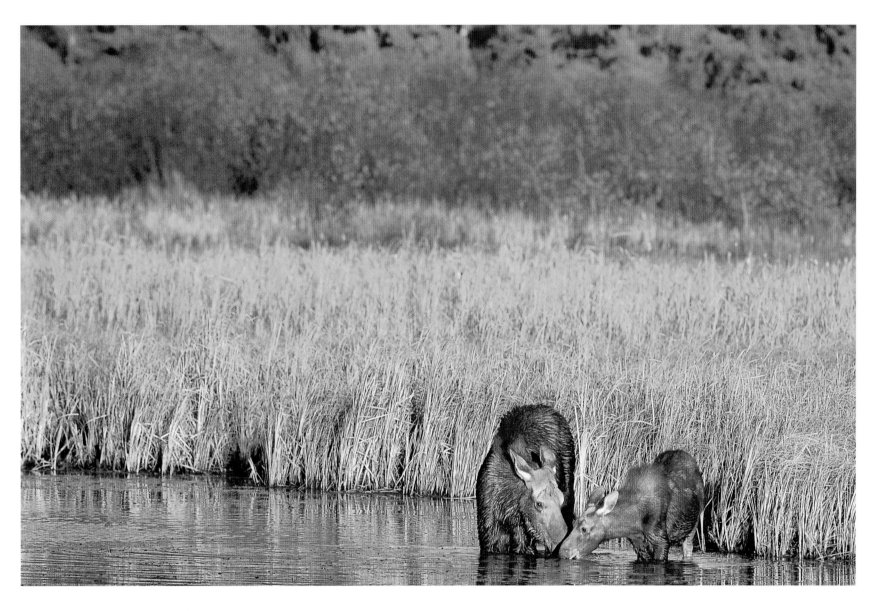

A cow moose and her calf stay close together in the marshlands of Ontario. The moose is the largest member of the deer family, and while it appears slow and serene, it can be extremely aggressive if provoked.

Around Flowerpot Island in Fathom Five National Marine Park, the waves have eroded the soft limestone to create striking rock pillars. Because dwarf trees and bushes are anchored to the tops of the pillars, they have been dubbed flowerpots. Once, this limestone was part of an ancient sea, and marine fossils remain in the stone.

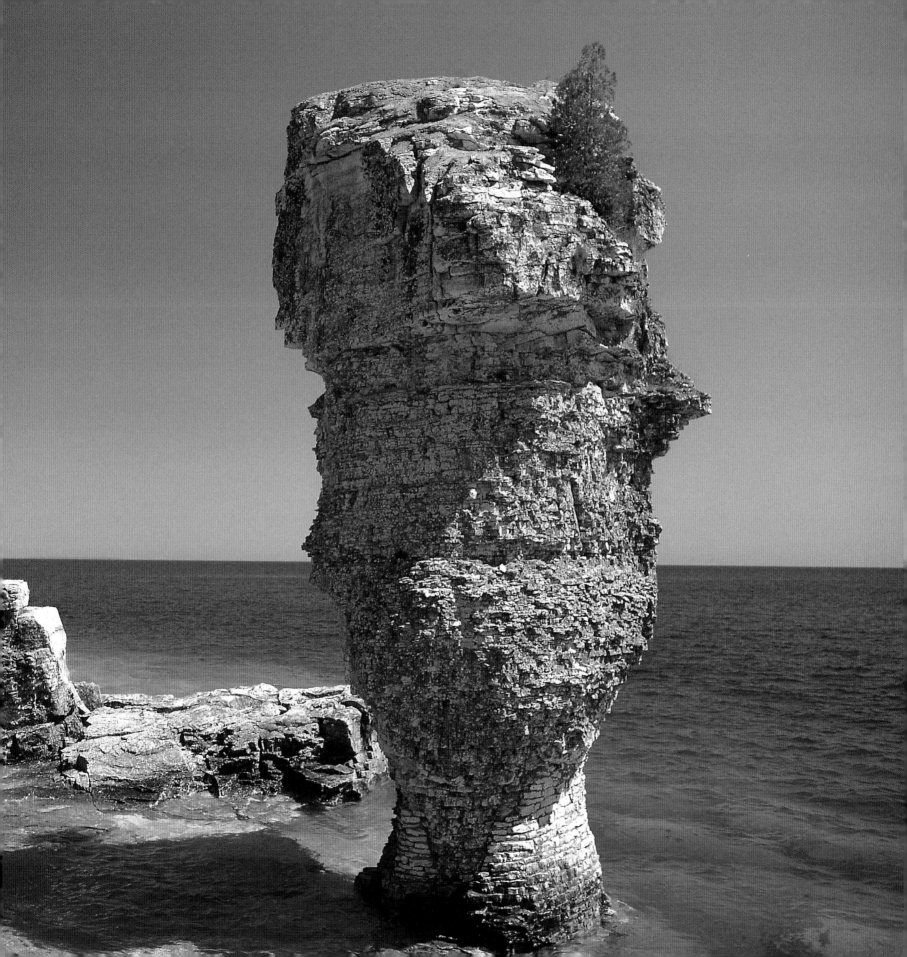

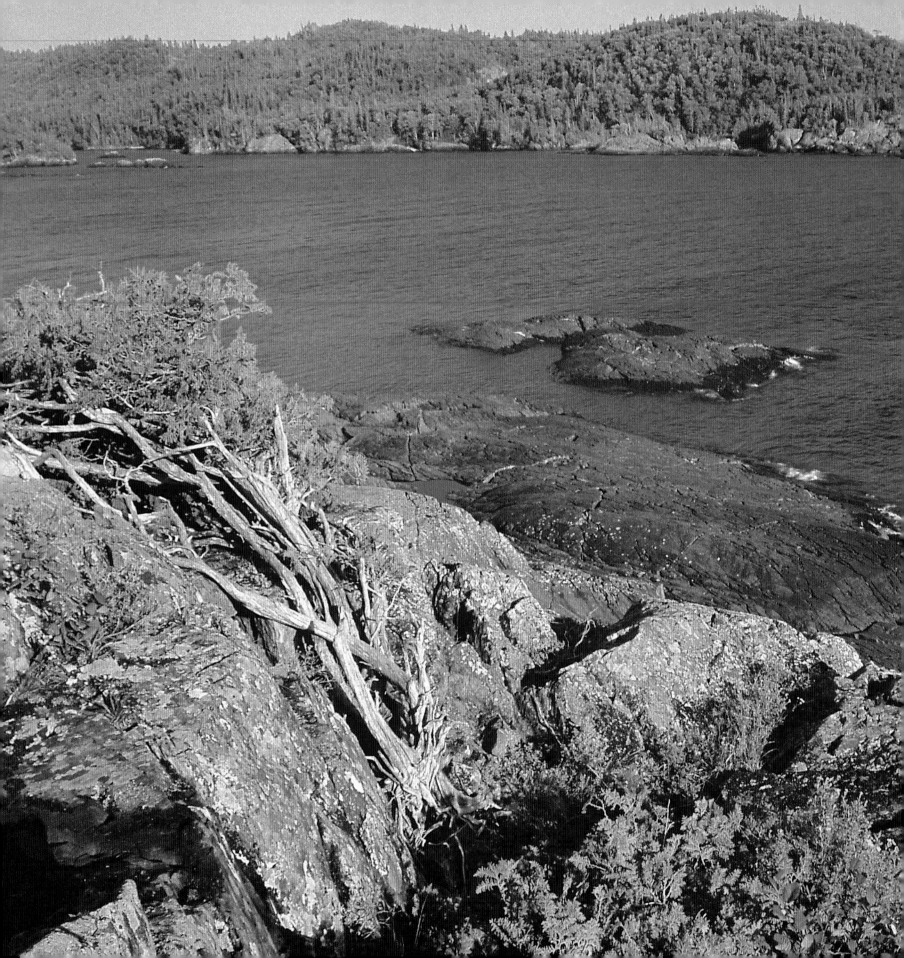

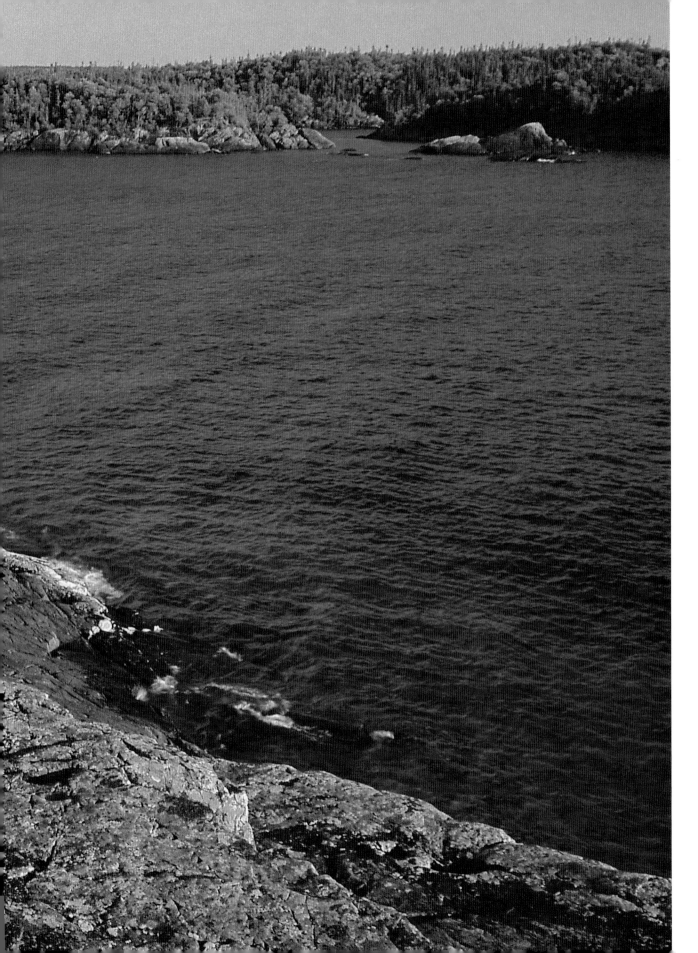

From the country's southernmost caribou herd to rare wild-flowers such as the lady's slipper, Pukaskwa National Park protects a wide. range of natural resources along the north shore of Lake Superior, the world's largest freshwater lake.

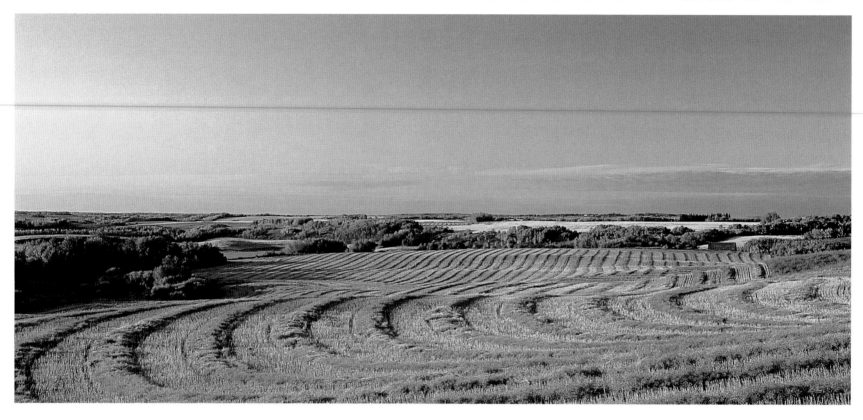

Manitoba's Riding Mountain National Park, home to the world's largest black bears, has been named a Biosphere Reserve by UNESCO. It serves as an international model of how humans and nature can co-exist.

Whirlpool Lake is one of several that dot Riding Mountain National Park, northwest of Winnipeg. A cabin nearby was built by Grey Owl, a renowned author and conservationist. Grey Owl was thought to be a native, but upon his death the public discovered that he was Archibald Stansfield Belaney, born in England.

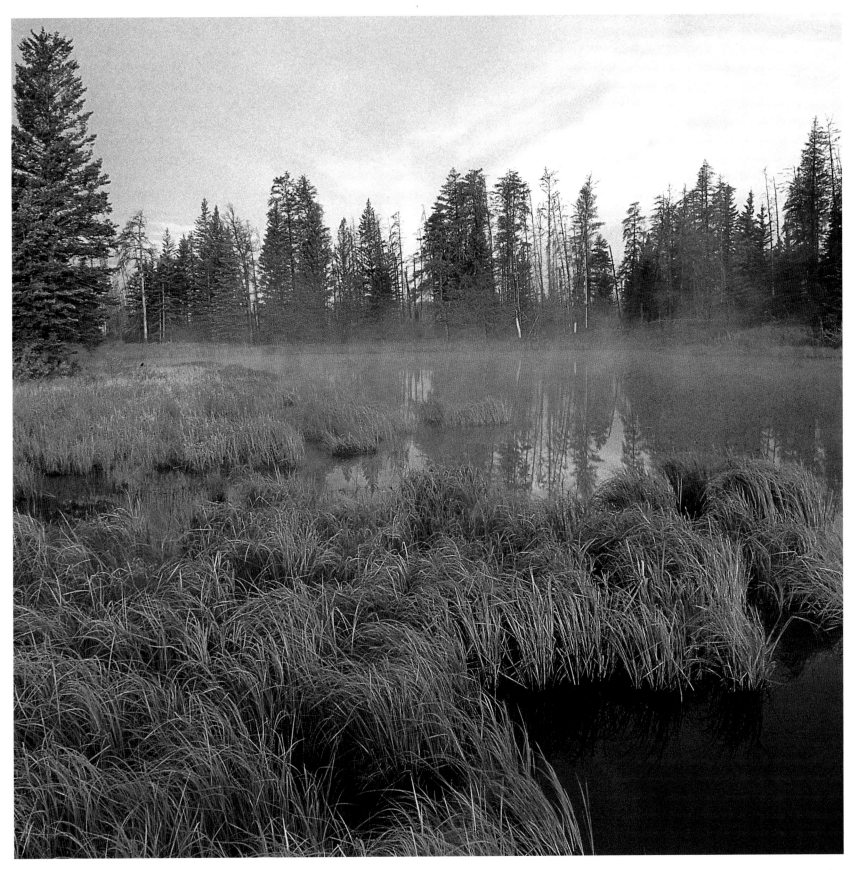

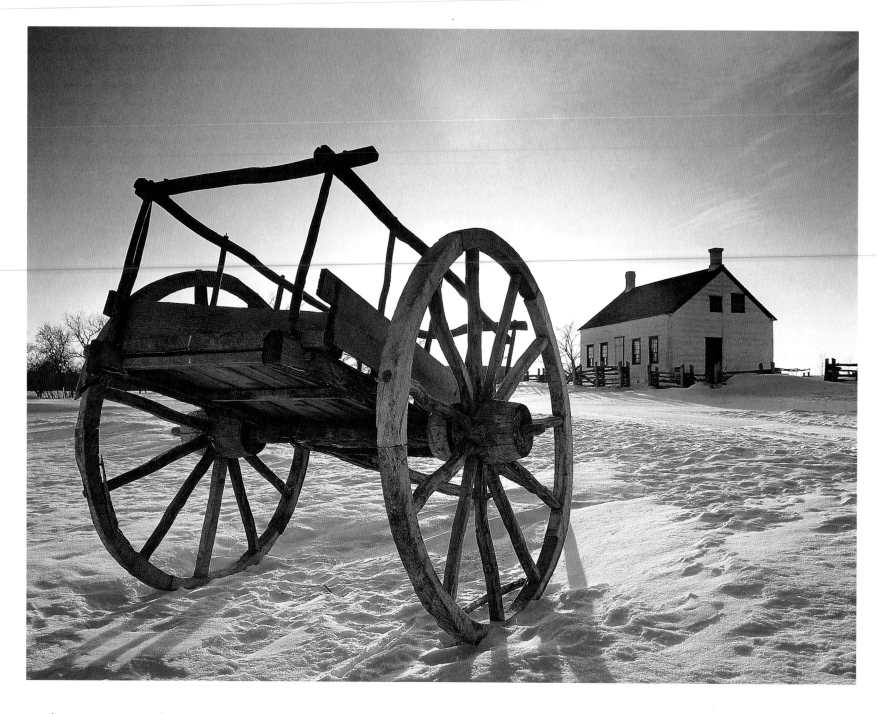

Red River carts, such as this one at Lower Fort Garry National Historic Site, were first used by prairie settlers in the early 1800s. They were later used extensively by the Hudson's Bay Company to carry furs from Canada to the Mississippi River, where the furs were loaded onto ships bound for Britain.

The Forks National Historic Site at the junction of the Assiniboine and Red rivers in Winnipeg commemorates the contributions of area fur traders and settlers. French explorer Pierre Gaultier founded Fort Rouge near here in 1837. The site was later a trading base for the North West Company and the Hudson's Bay Company.

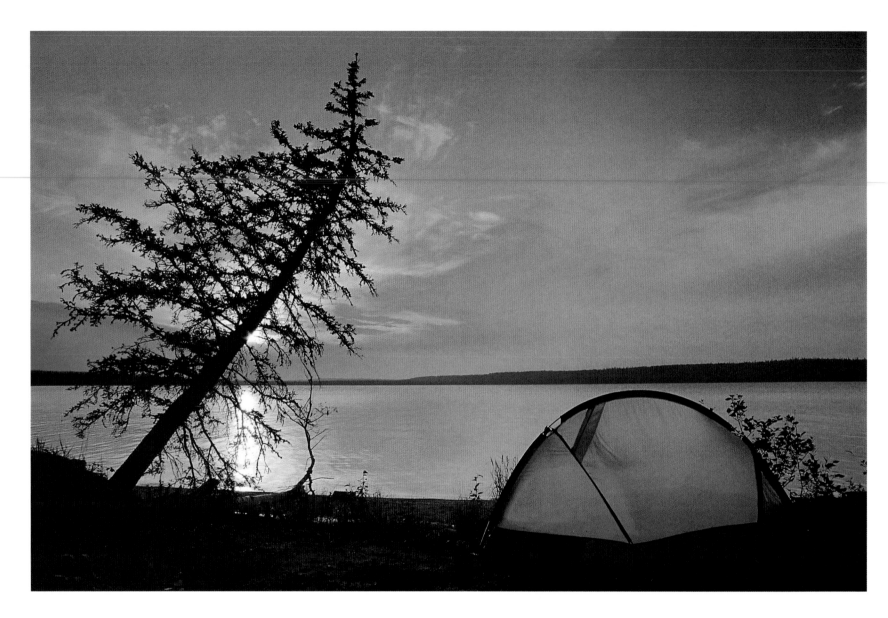

Saskatchewan's Prince Albert National Park encompasses hundreds of tiny lakes and several large ones, including Waskesiu Lake. Trails throughout the park are ideal for hiking, cross-country skiing, or cycling.

An eerie sky turns Trappers Lake a vivid blue. Marsh-like areas such as this one help to protect almost 200 different bird species within Prince Albert National Park.

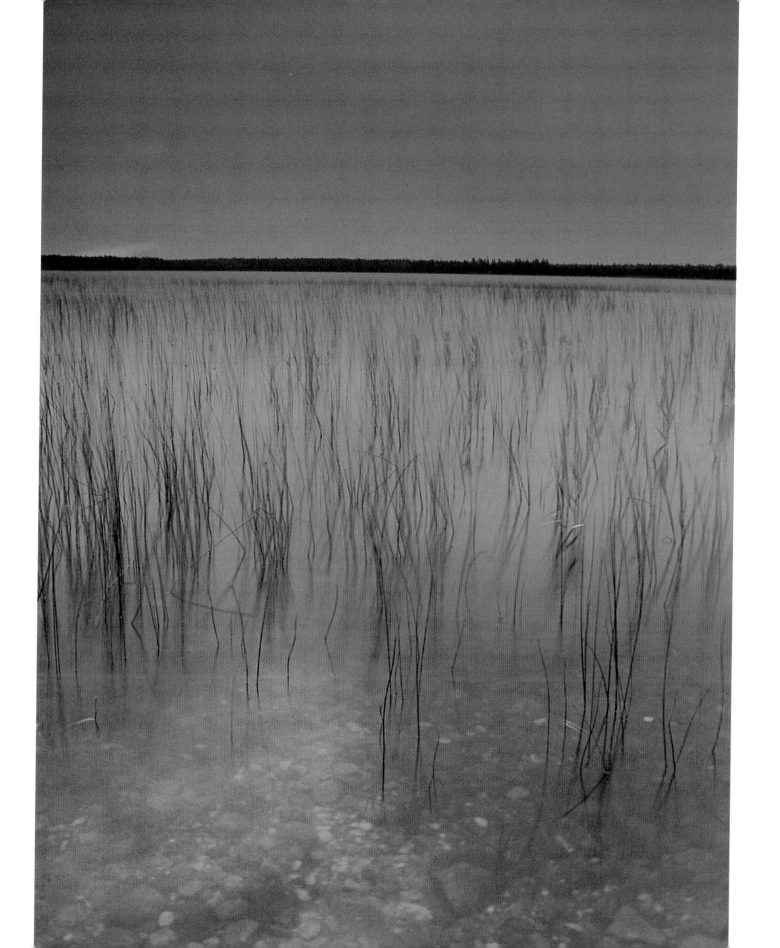

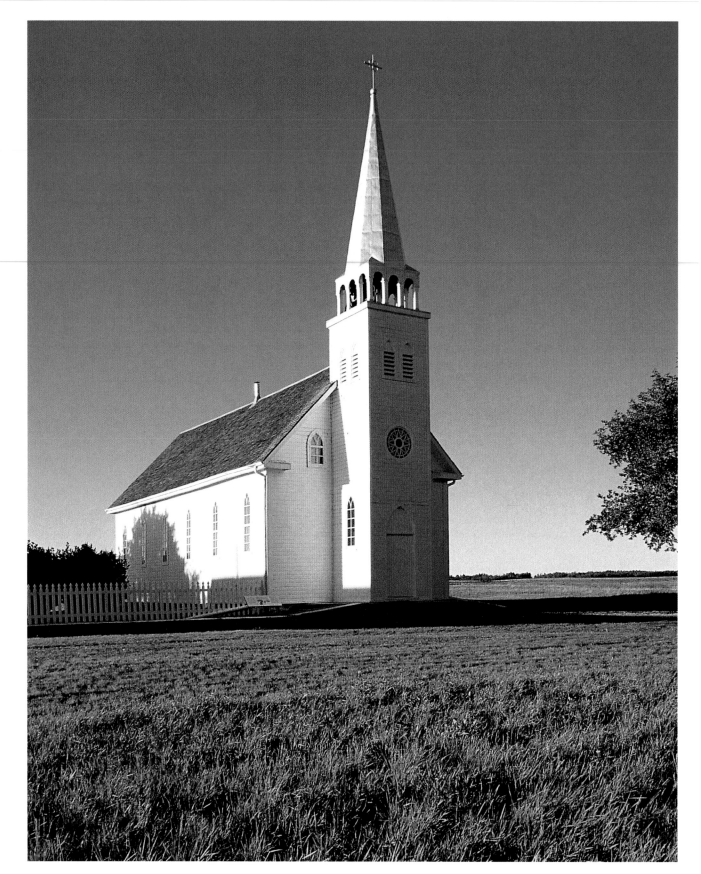

The church and rectory are all that remain of the Métis village where Louis Riel and his followers were defeated in May 1885. Batoche National Historic Site commemorates the doomed rebellion and the struggle of the Métis people.

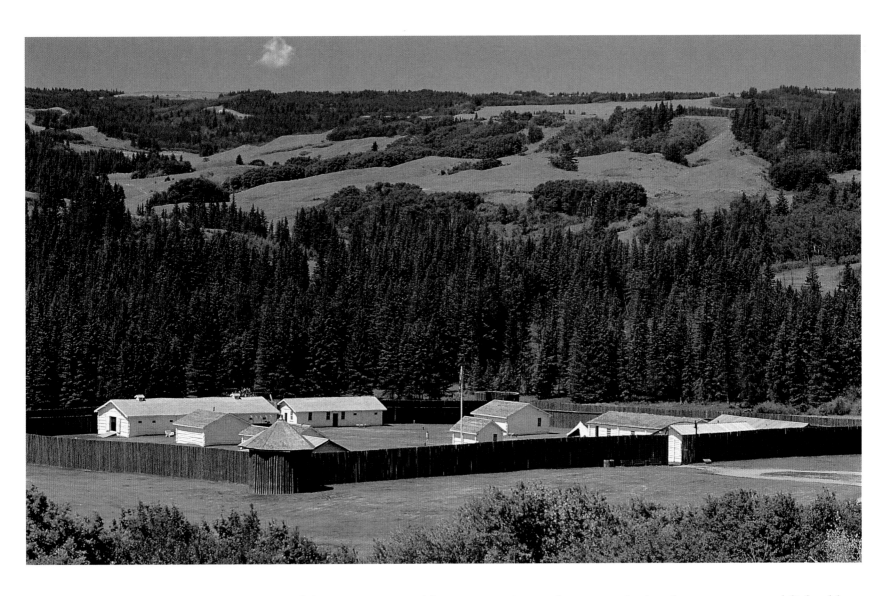

Fort Walsh, now a national historic site in southwestern Saskatchewan, was established by the North-West Mounted Police in response to unrestricted whiskey and fur trading in the late 1800s. In 1873, wolf hunters killed 20 natives near here in what is now known as the Cypress Hills Massacre.

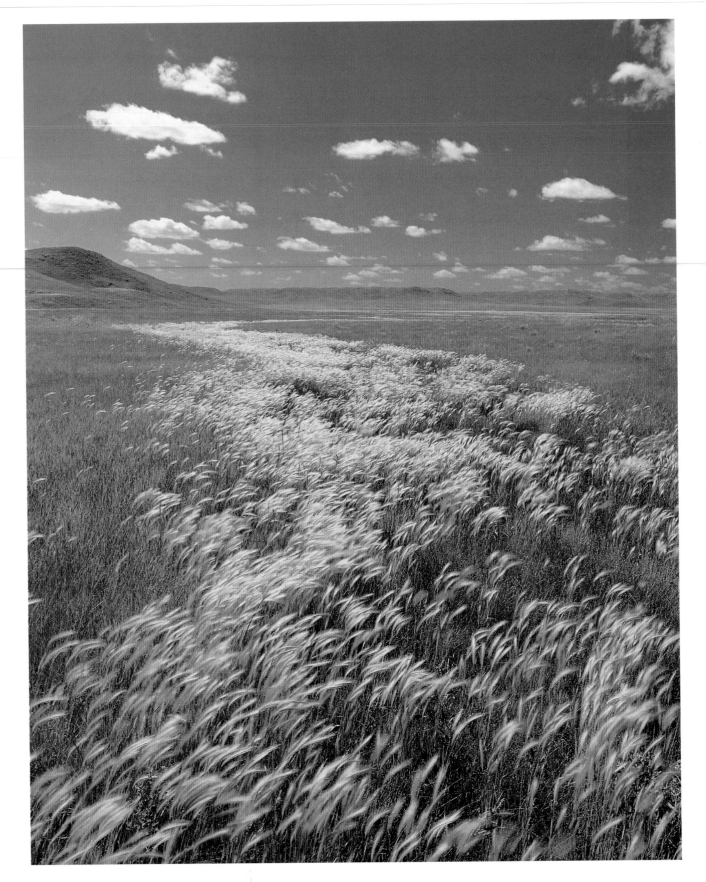

Though some of the land in Saskatchewan's Grasslands National Park was farmed by settlers in the early part of the century, since 1975 the government has attempted to preserve some of the undisturbed prairie. Supporters hope the park will increase in size through the purchase of additional land now privately owned by ranchers.

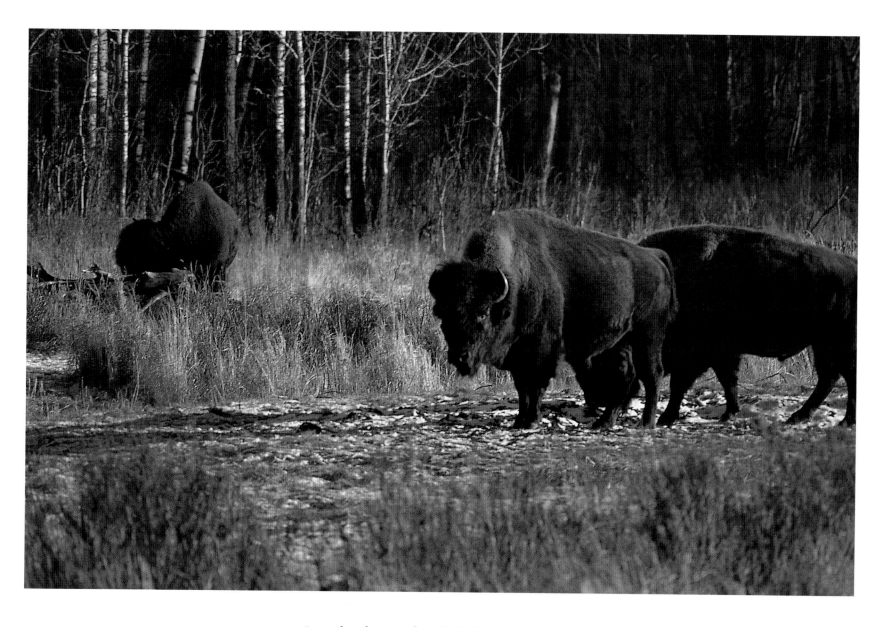

Canada's largest herd of plains bison, about 350 animals, roams Elk Island National Park in Alberta. Hunting almost drove the bison to extinction, but with government protection the population is slowly increasing. The park is also home to a herd of wood bison, the largest land animals in North America.

OVERLEAF –
A lone canoeist enjoys the serenity of Astotin Lake in Elk Island National Park. The government established the park in 1913 to protect elk from overhunting.

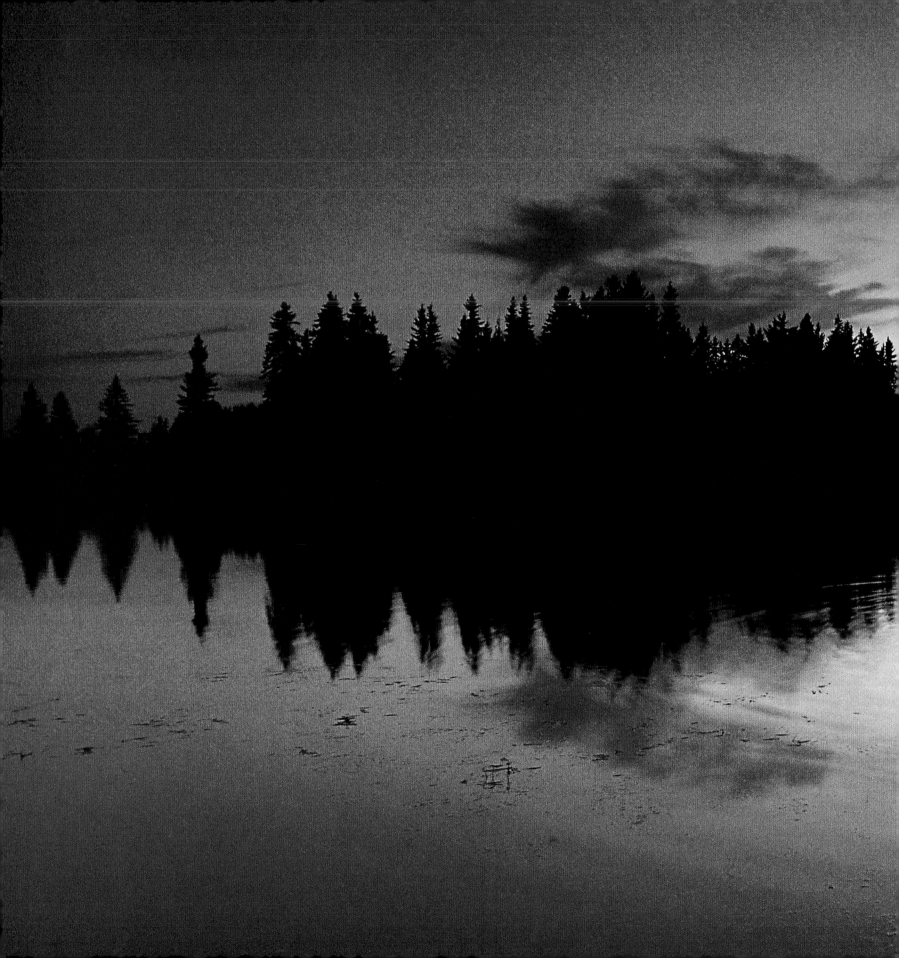

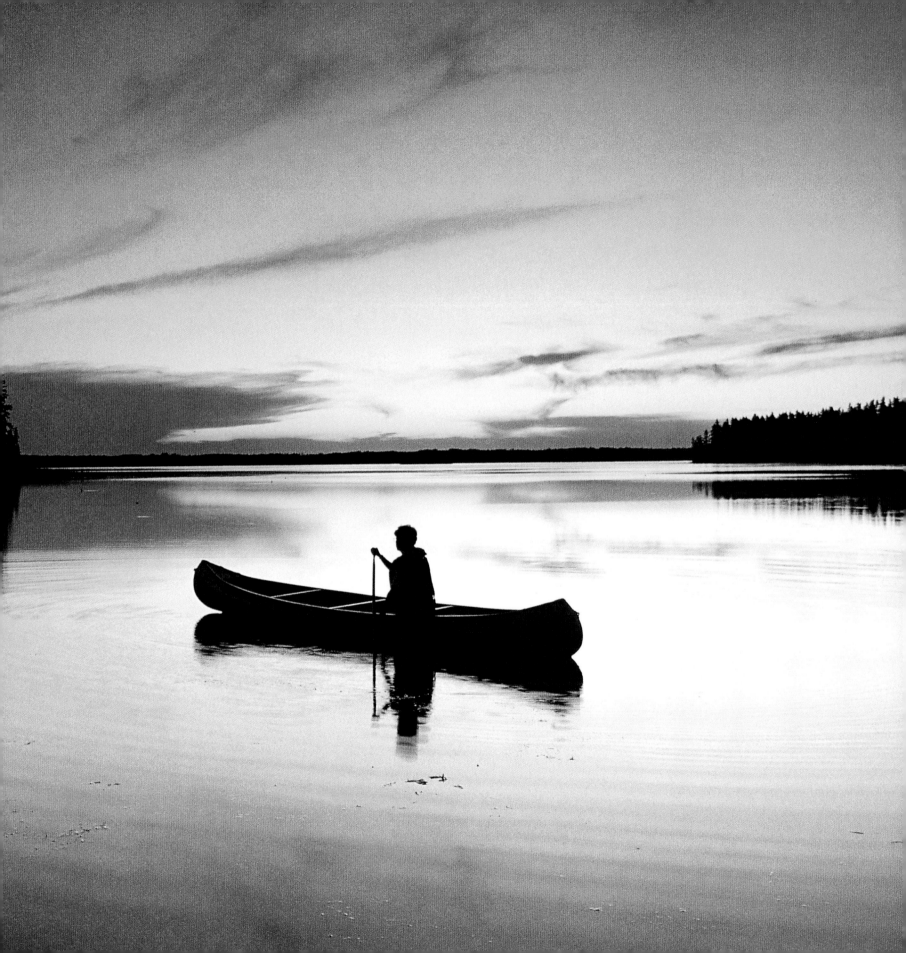

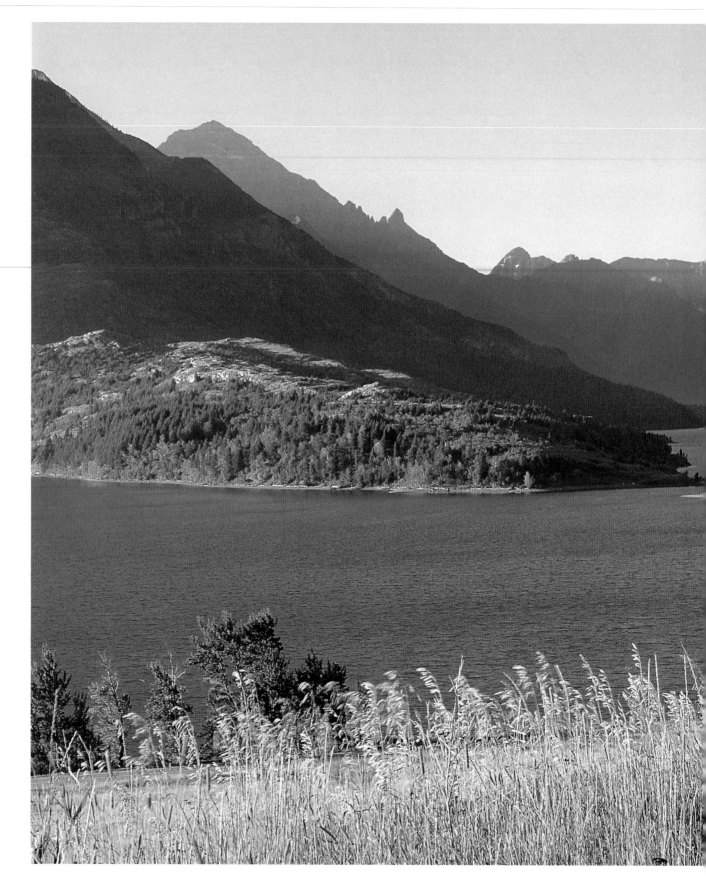

The Prince of Wales Hotel in Waterton Lakes National Park was built by the Great Northern Railway, an American company with a chain of resorts on the other side of the border. This luxurious hotel continues to serve Canadians, Americans, and visitors from overseas.

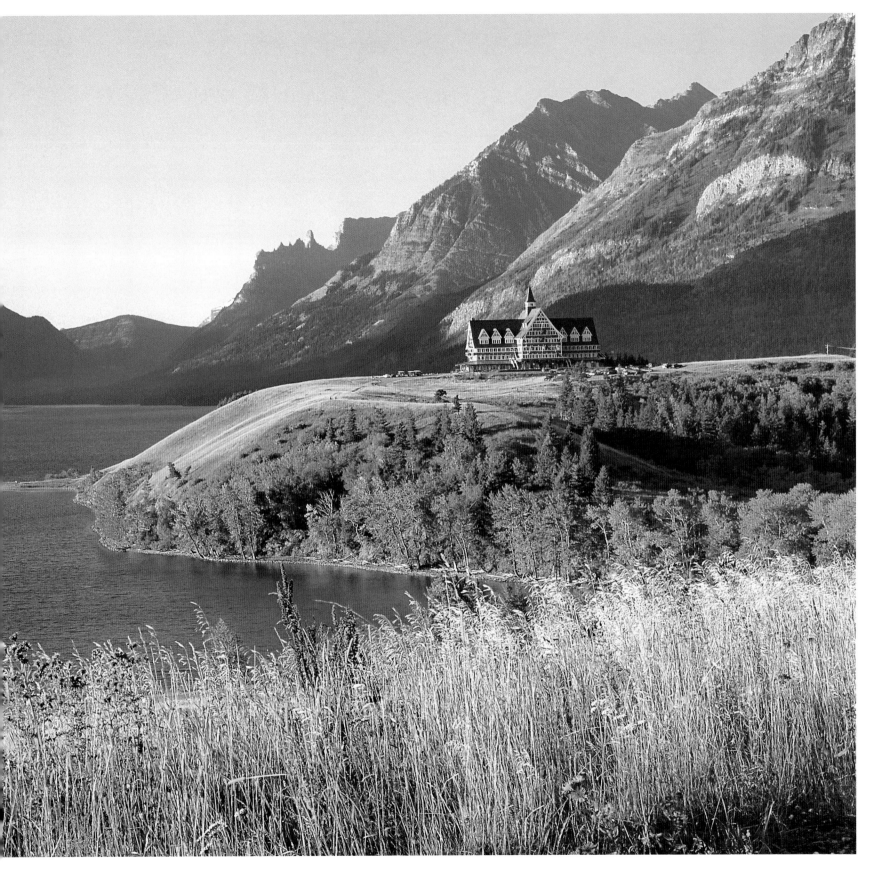

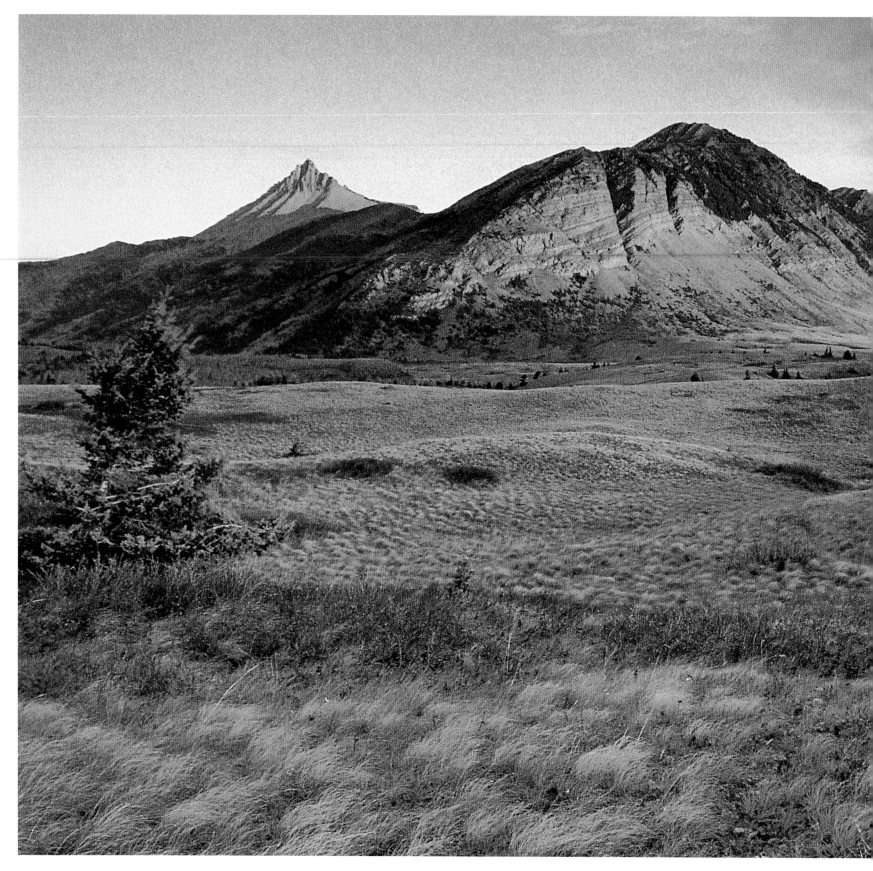

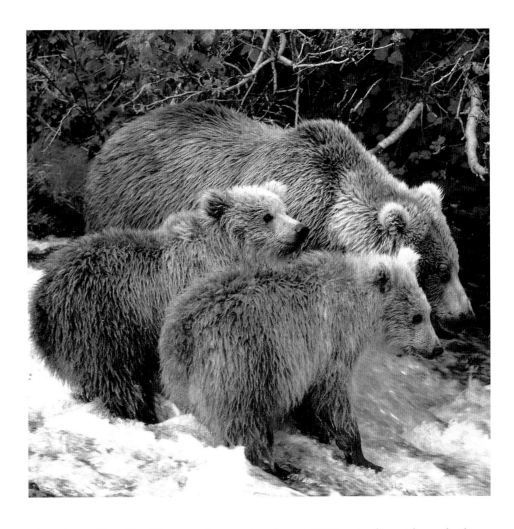

The Canadian Rockies are home to about 2000 grizzlies, though they are threatened by encroaching development. Grizzlies are easily recognized by the distinctive hump above their shoulders. Their forepaws are more than twice the size of a human hand.

The Waterton-Glacier International Peace Park encompasses part of Alberta's Waterton Lakes National Park and Montana's Glacier National Park in the world's first such international reserve. The park was proposed in the early 1900s by explorer Kootenai Brown and park ranger Henry Reynolds—a man whose fast-paced hiking earned him the nickname "death on the trail."

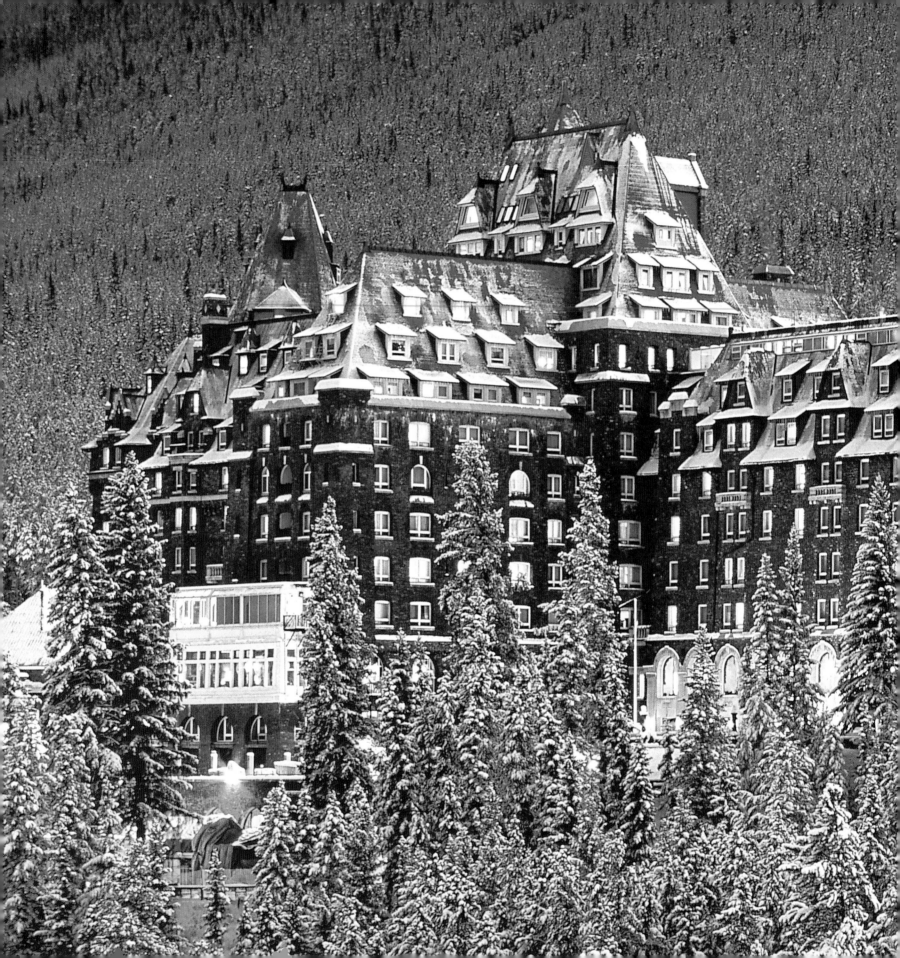

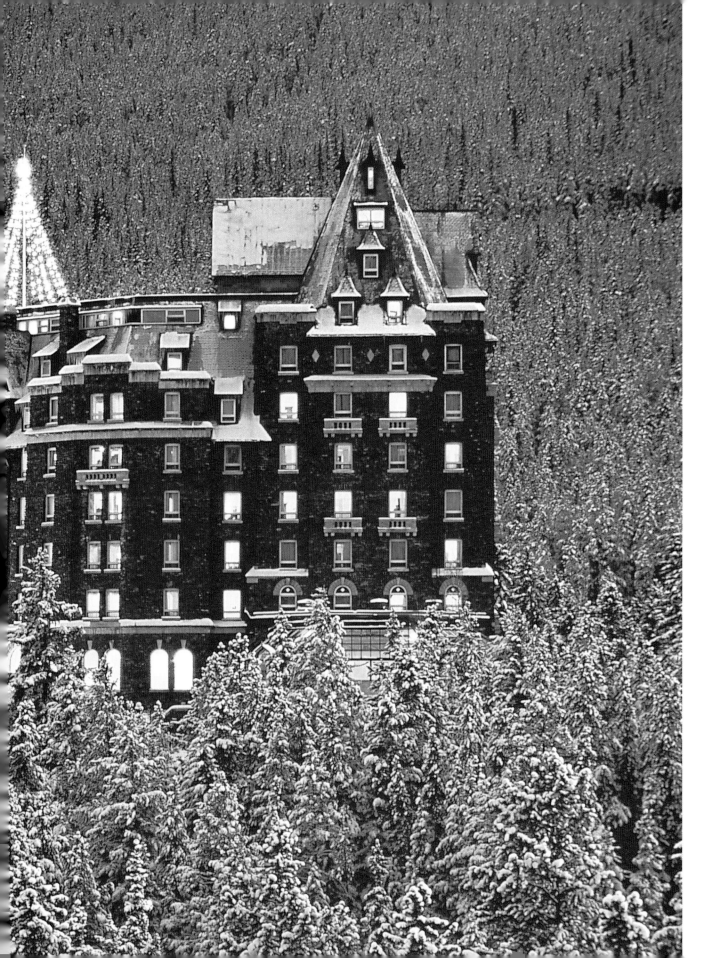

When it opened in 1888, the 250-room Banff Springs Hotel was the largest hotel on earth and rooms were $3.50 a night. Prices have gone up, but the hotel still draws guests from around the world.

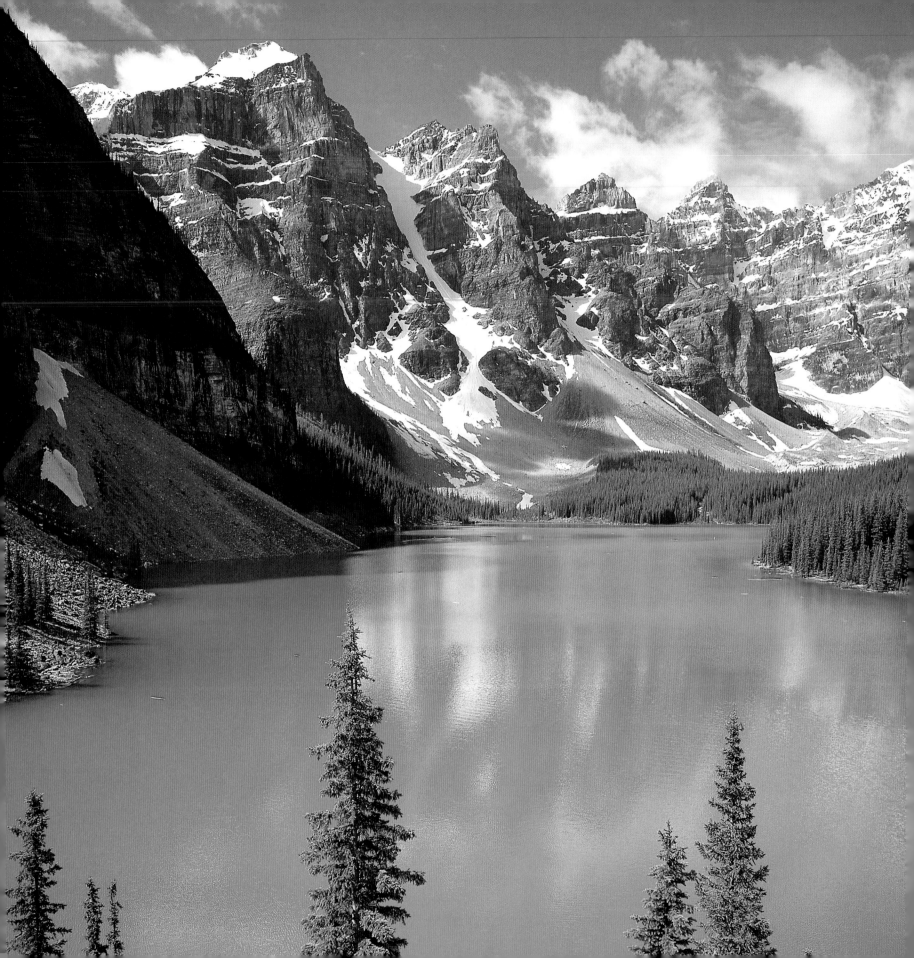

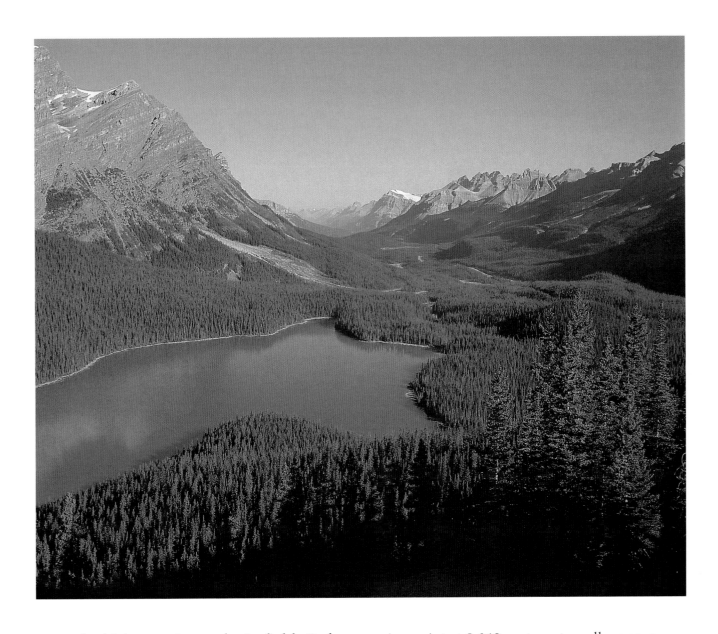

From the highest point on the Icefields Parkway, a viewpoint at 2,069 metres, travellers gaze down on the deep blue expanse of Peyto Lake. The lake is named after Bill Peyto, a British outfitter whose knowledge of the Rockies made him one of the area's most respected guides.

Canadians may recognize this view—Moraine Lake in Banff National Park was shown on the back of the old twenty-dollar bill. The lake is surrounded by the Valley of the Ten Peaks, named by climber Samuel Allen.

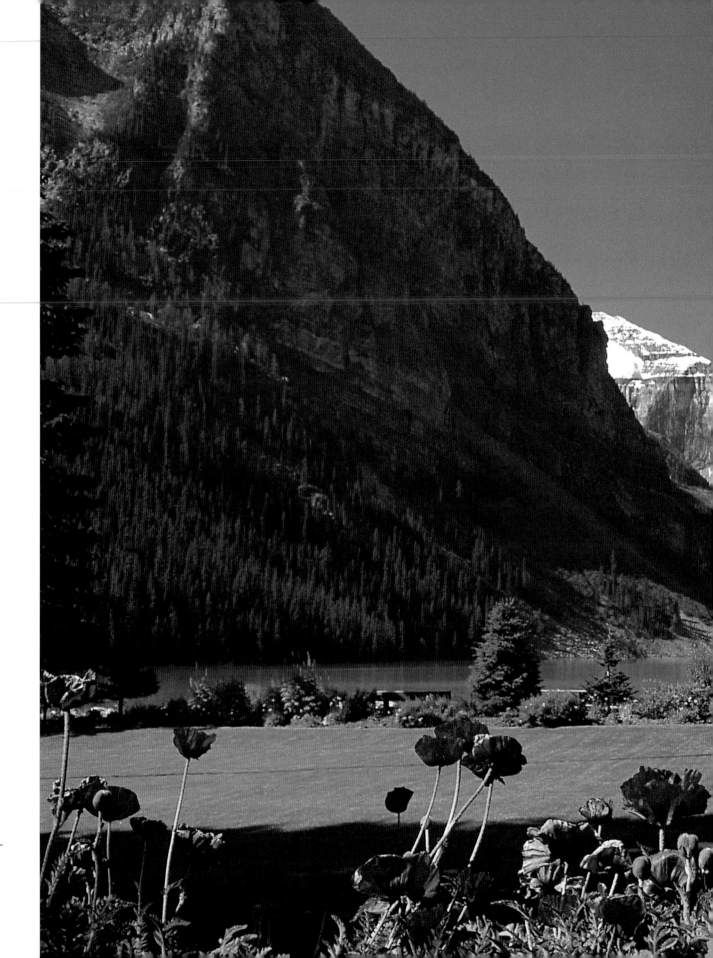

Established in 1885, Banff National Park was Canada's first national preserve. It now attracts four million visitors per year. Crystal-blue Lake Louise is one of the park's most popular destinations.

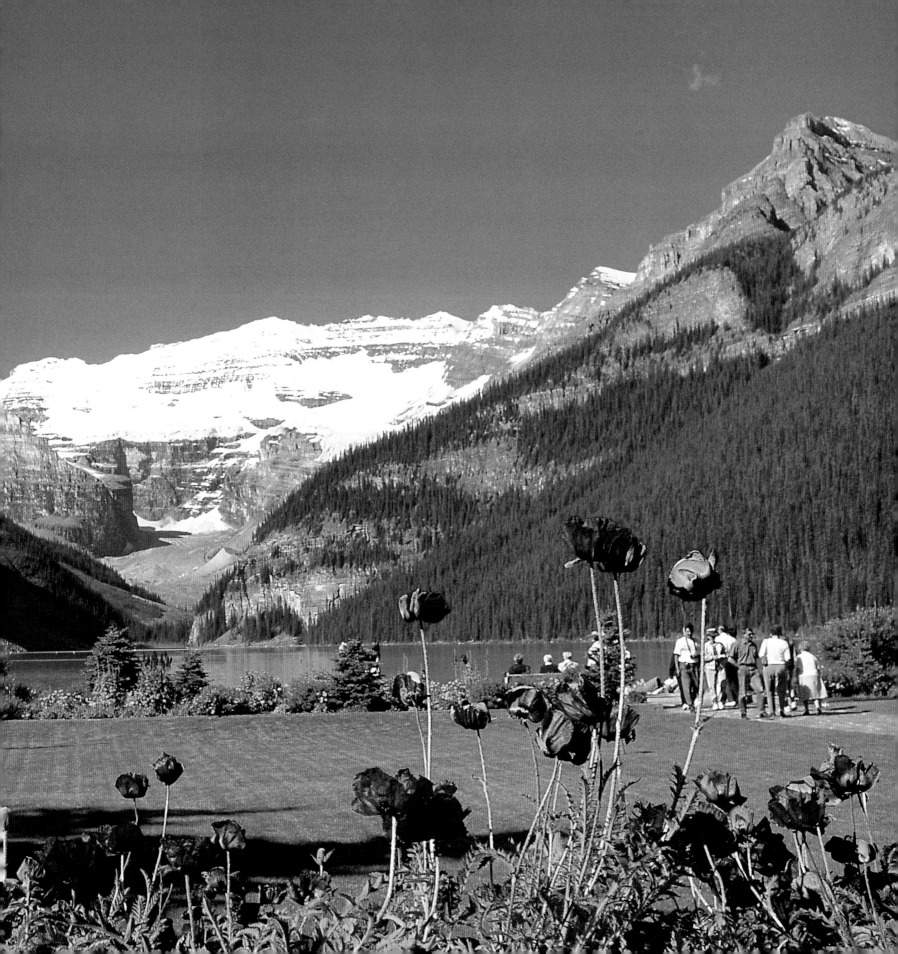

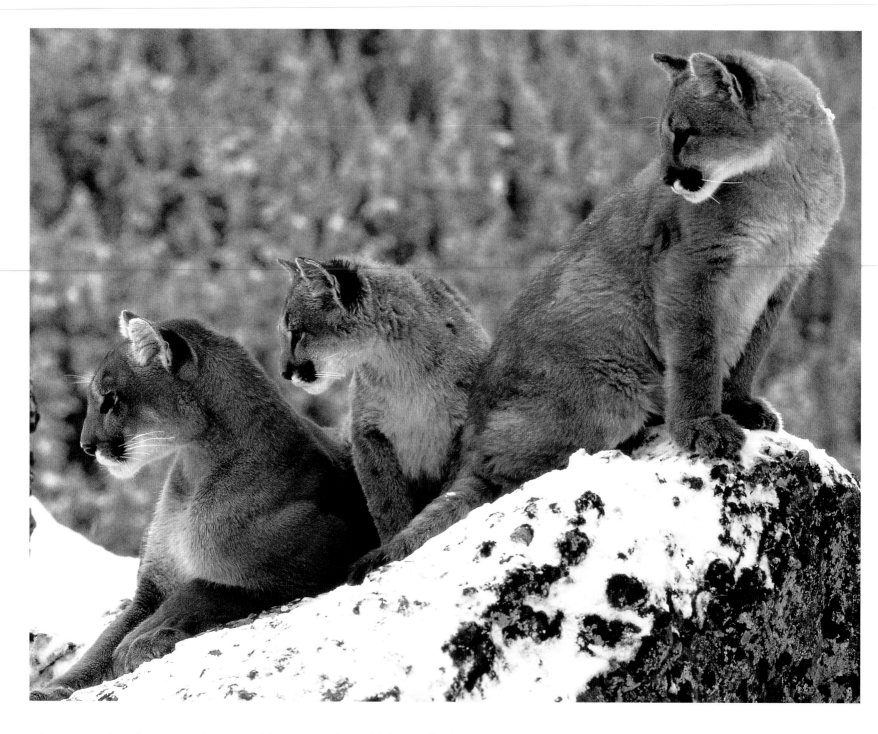

The cougar is a ferocious hunter, able to attack and kill an elk three times its size. Its smaller cousins, the lynx and the bobcat, are more likely to hunt rodents and birds.

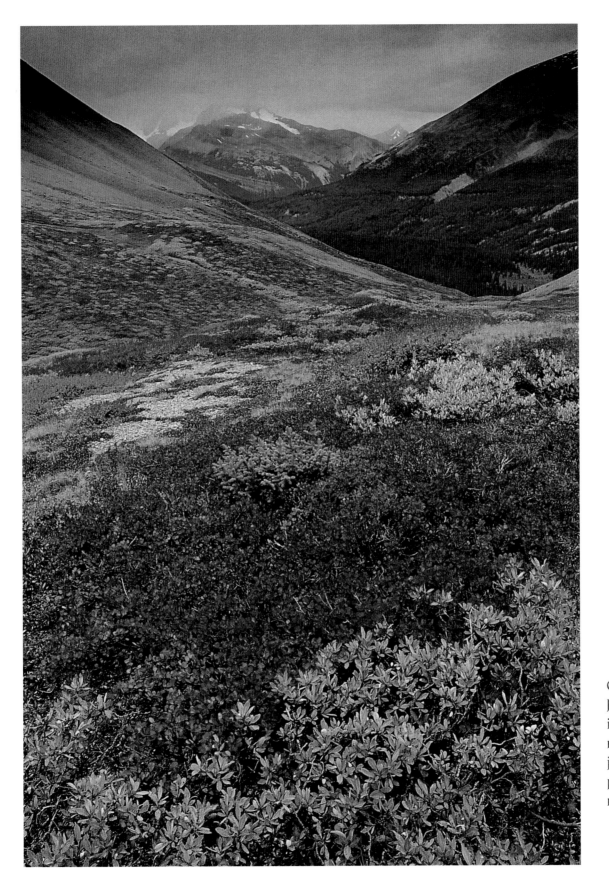

Only one-tenth of
Jasper National Park
is valley bottoms. The
rest is pure height—
jagged cliffs, glaciers,
peaks, and alpine
meadows.

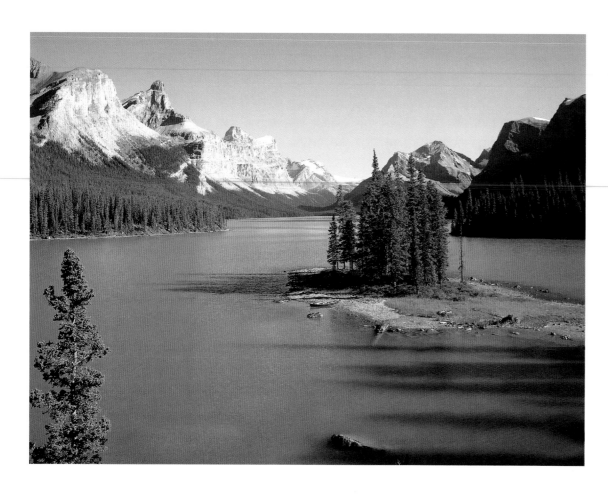

At 22 kilometres long and 97 metres deep, Maligne
Lake in Jasper National Park is the largest glacier-fed
lake in the Canadian Rockies.

Along with Banff, Yoho, and Kootenay national
parks, Jasper is part of the Rocky Mountain World
Heritage Site. Together, these parks protect 69
mammal species, and provide the range needed
by large animals such as grizzly bears.

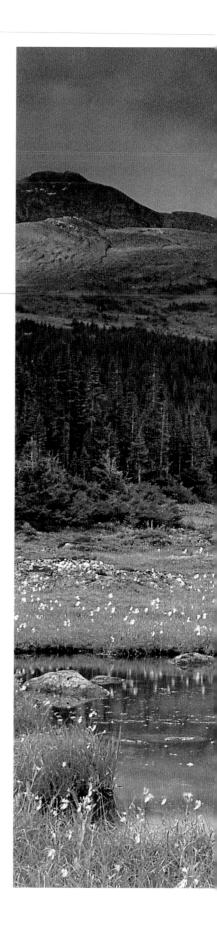

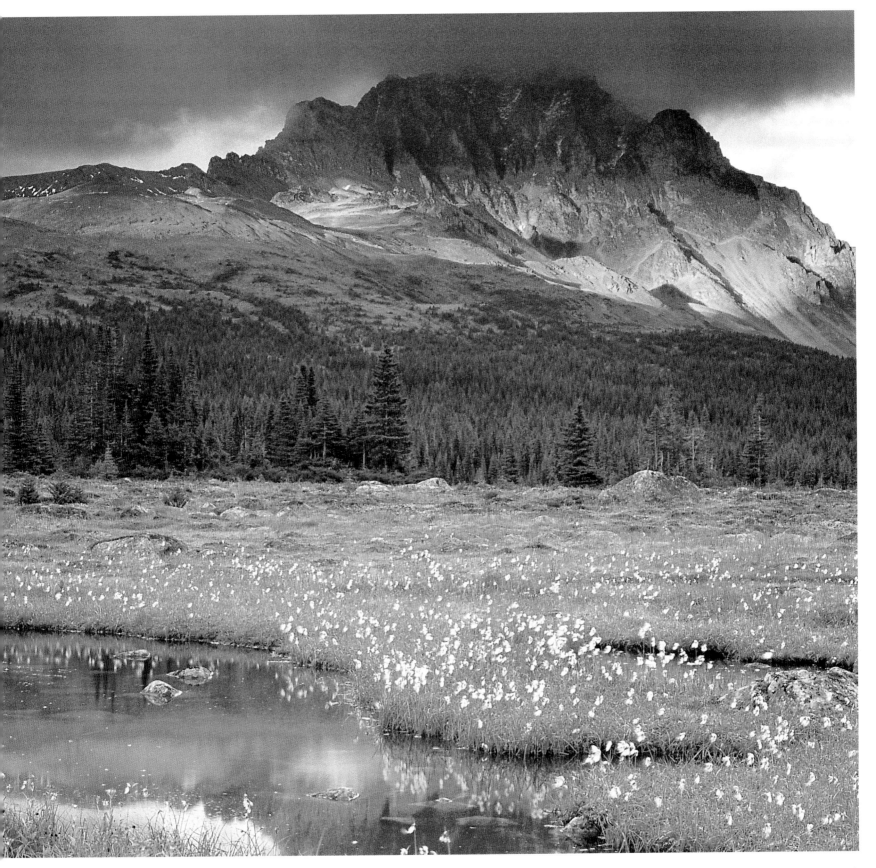

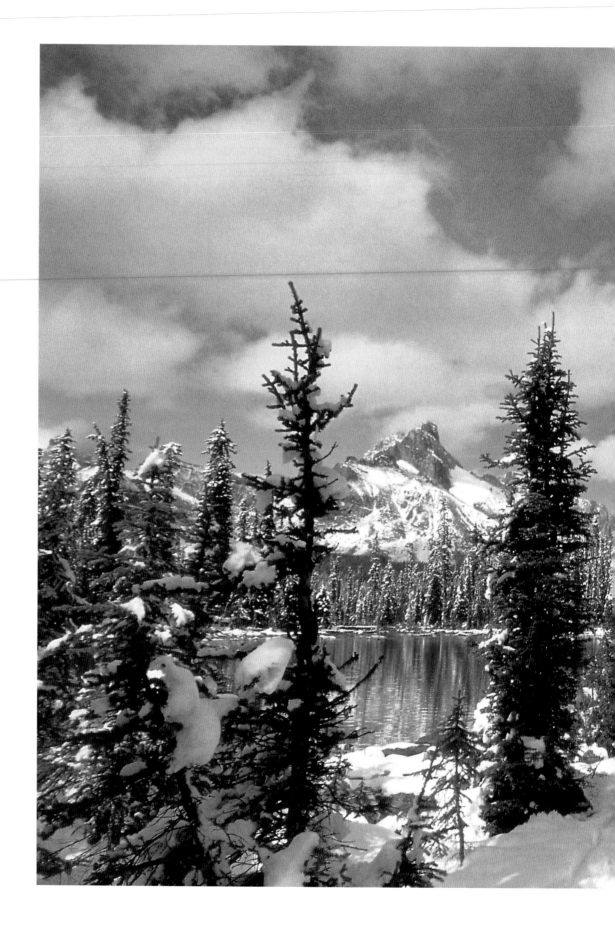

Lake O'Hara in British Columbia's Yoho National Park is a popular base for hiking and cross-country skiing. More than 360 kilometres of trails crisscross the park.

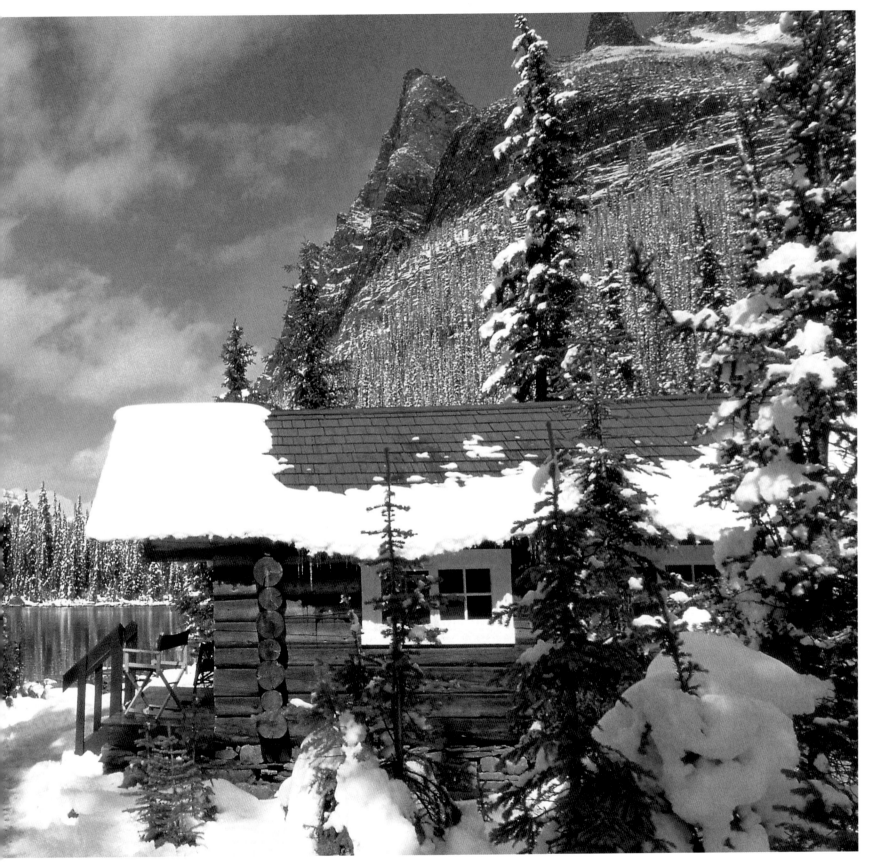

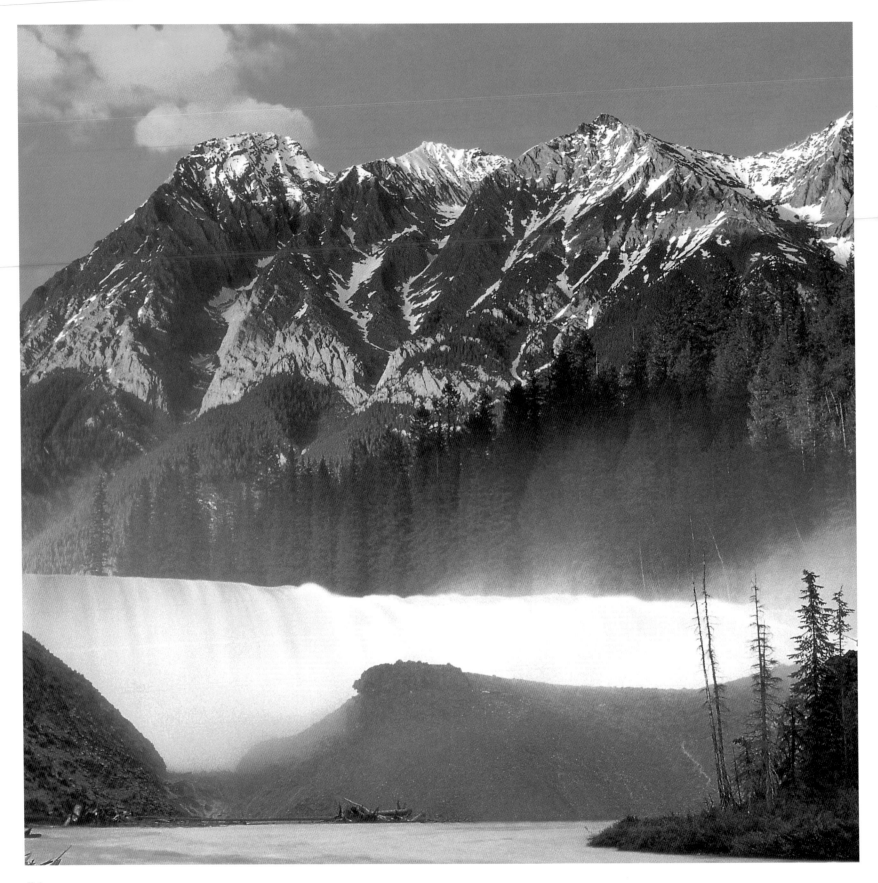

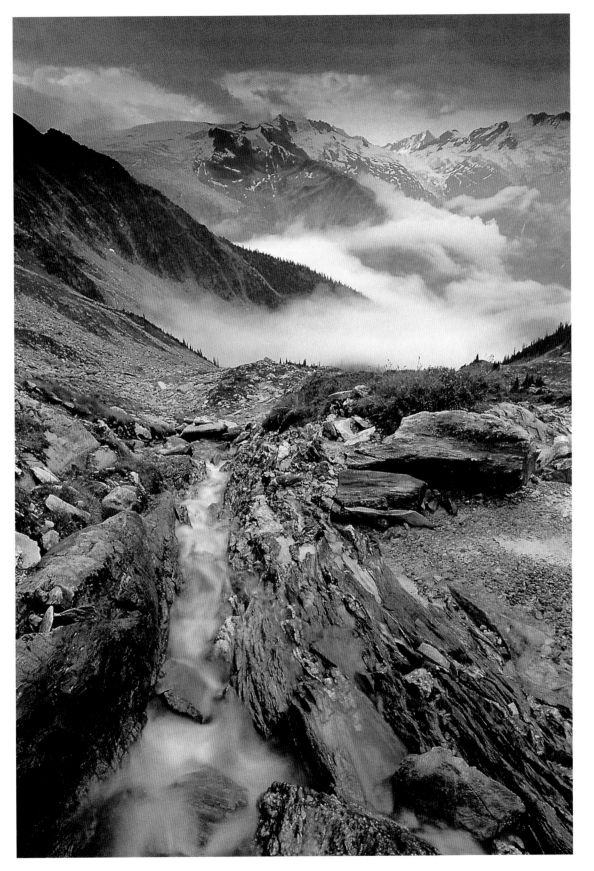

More than 400 glaciers cleave the peaks of Glacier National Park, in the rugged Selkirk and Purcell Range near Golden, B.C. The Canadian Pacific Railway once hugged the slopes of these mountains. After avalanches and extreme weather killed more than 250 workers, the railway built the present tunnel, leaving the peaks above to caribou, grizzly bears, and experienced hikers.

FACING PAGE –
At the peak of the spring run-off, 255 cubic metres a second pour over Wapta Falls into the Kicking Horse River. The waterfall is just part of the spectacular scenery that characterizes Yoho National Park.

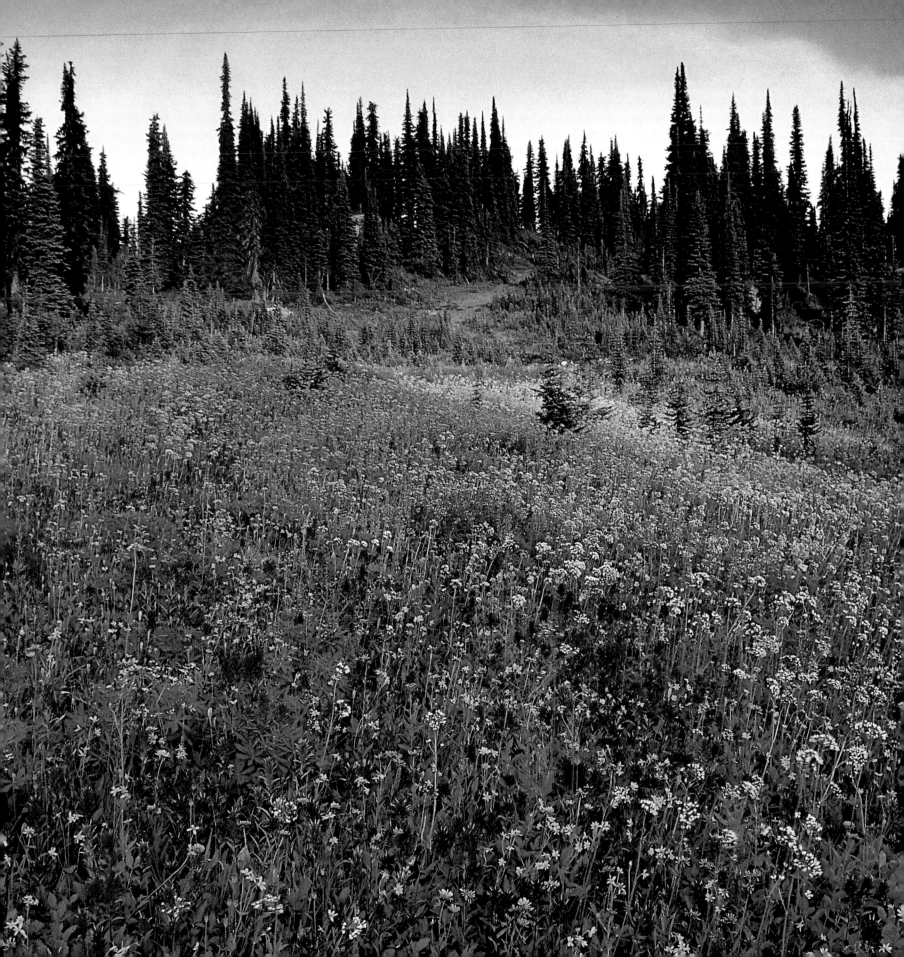

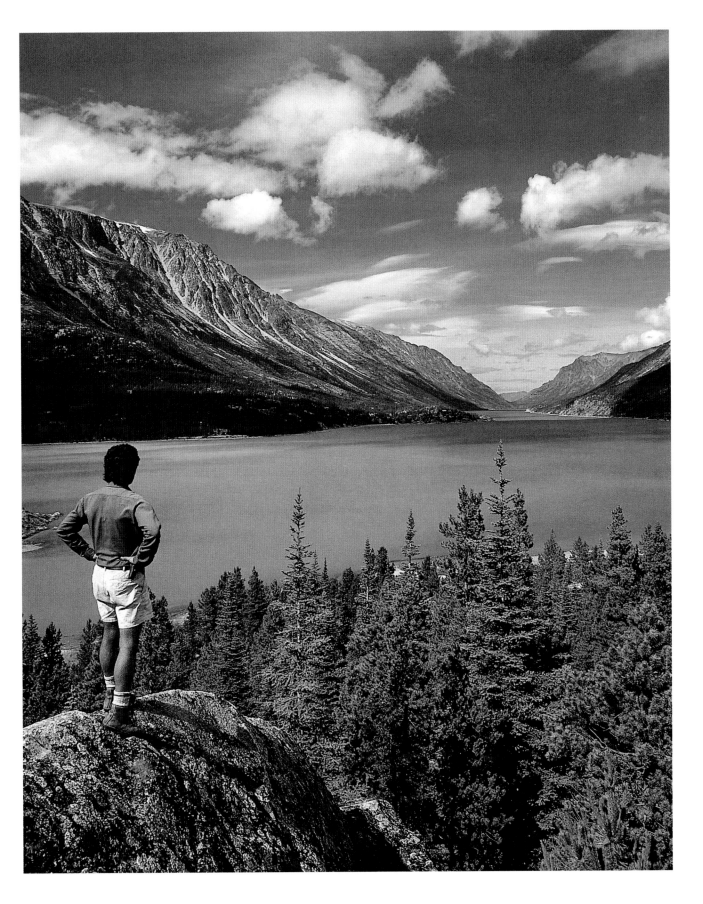

In the 1890s, long lines of travellers toiled over the Chilkoot Trail from Skagway, Alaska, to Bennett Lake, B.C. Many came in search of the fabled, and never-found, mother lode of Klondike gold. The hazardous trail is now a national historic site.

FACING PAGE –
Some of Mount Revelstoke National Park's peaks and meadows are buried under a year-round layer of snow. Those that escape burst into a colourful summer display of wildflowers.

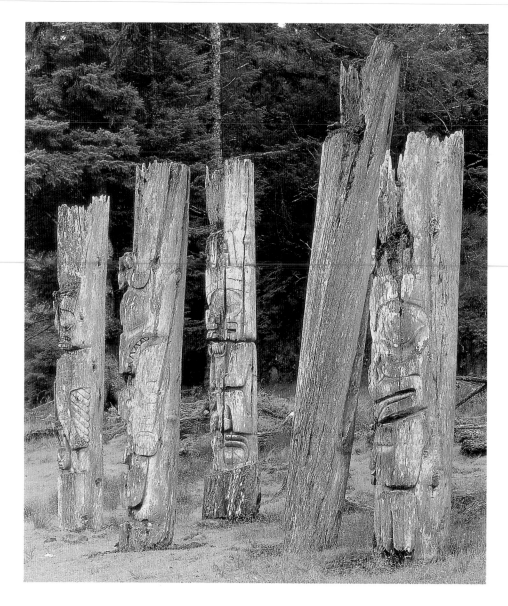

Weather-worn totems and fallen house timbers are all that remain of the once-thriving village of Ninstints, where smallpox killed most of the native population. Gwaii Haanas National Park now protects the poles, and the area has been declared a UNESCO World Heritage Site.

Sitka spruce, red cedar, and western hemlock old-growth forests greet visitors to Pacific Rim National Park. One of the park's main attractions is the 72-kilometre West Coast Trail, which draws more than 9000 hikers each year. Originally built for the workers who serviced the telegraph wire between Victoria and Cape Beale, the route was improved in the early 1900s to allow rescuers to reach shipwreck survivors.

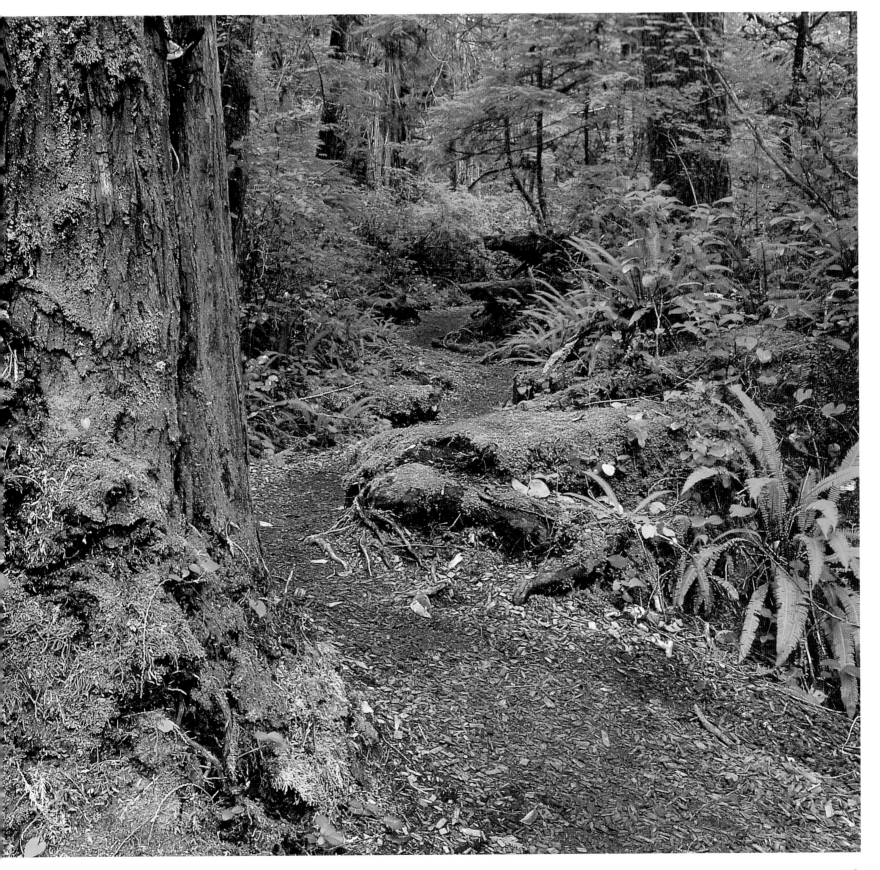

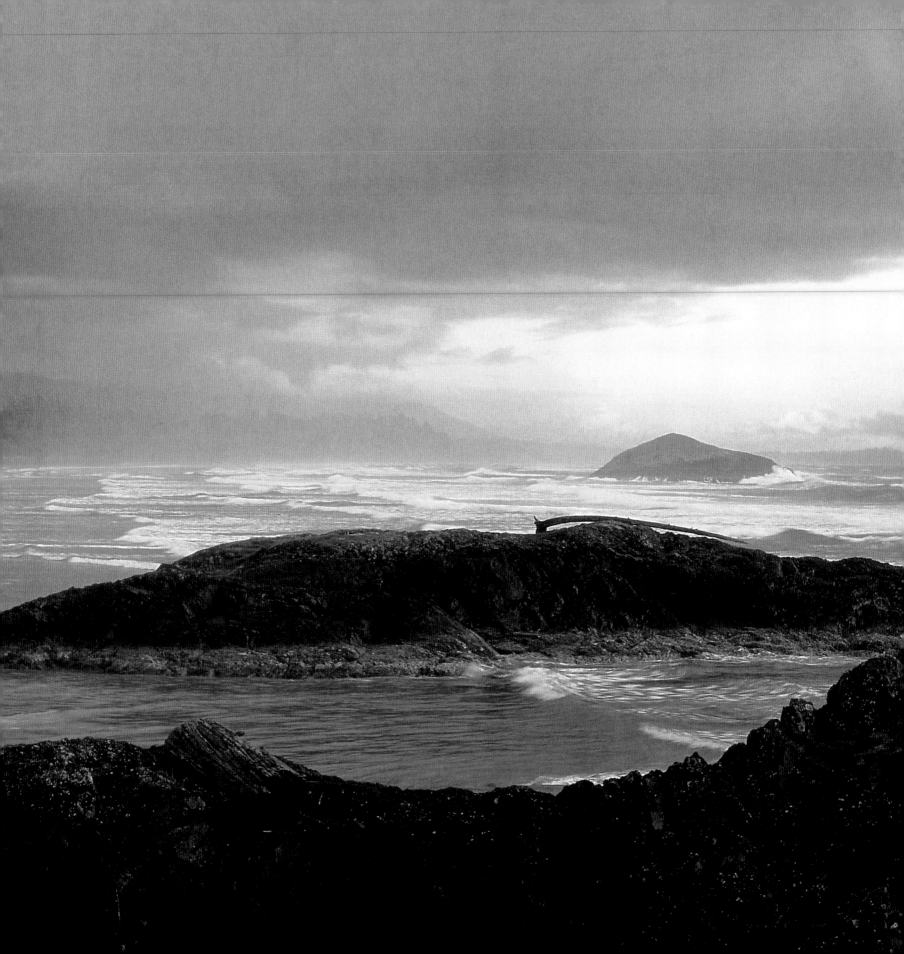

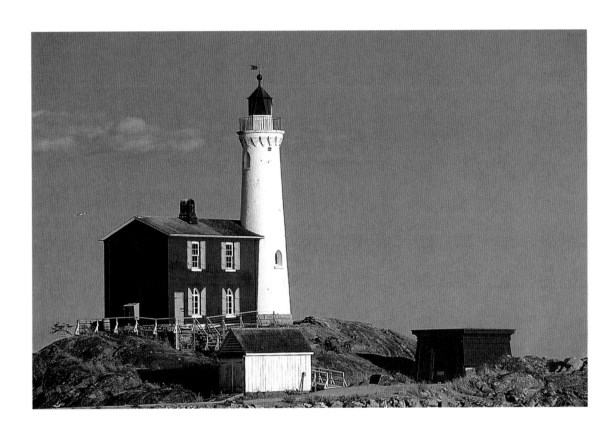

Since 1869, Fisgard Lighthouse has alerted ships approaching Esquimalt, British Columbia. The lighthouse is now protected as a national historic site.

The Long Beach section of Pacific Rim National Park stretches for 30 kilometres south of Tofino on Vancouver Island. Harsh storms batter the shore each winter. In spring, visitors gather on the sand to watch for migrating grey whales.

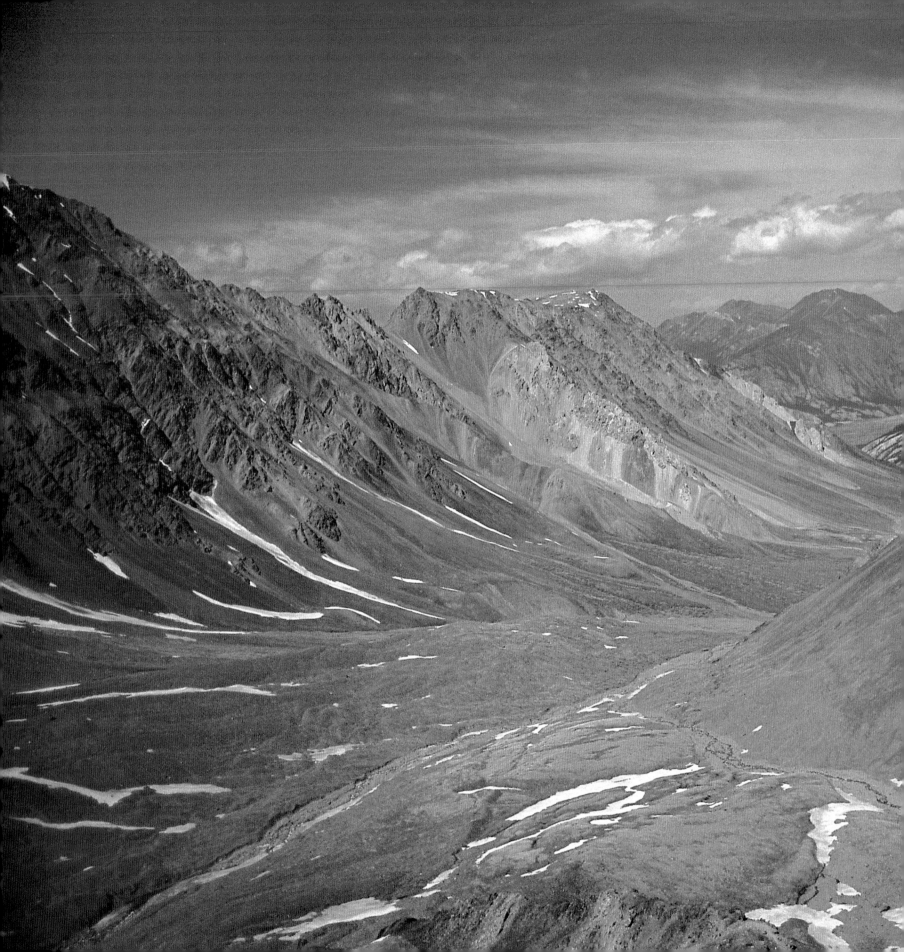

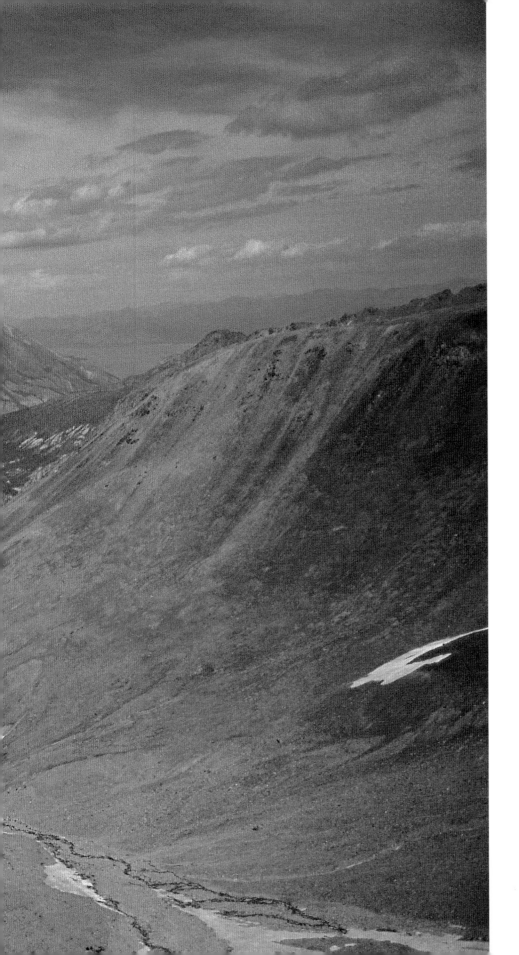

The Slims River Valley cuts through the towering mountains of Kluane National Park in the Yukon. In contrast to the barren heights, the park's valleys harbour the greatest diversity of plants and birds north of the 60th parallel.

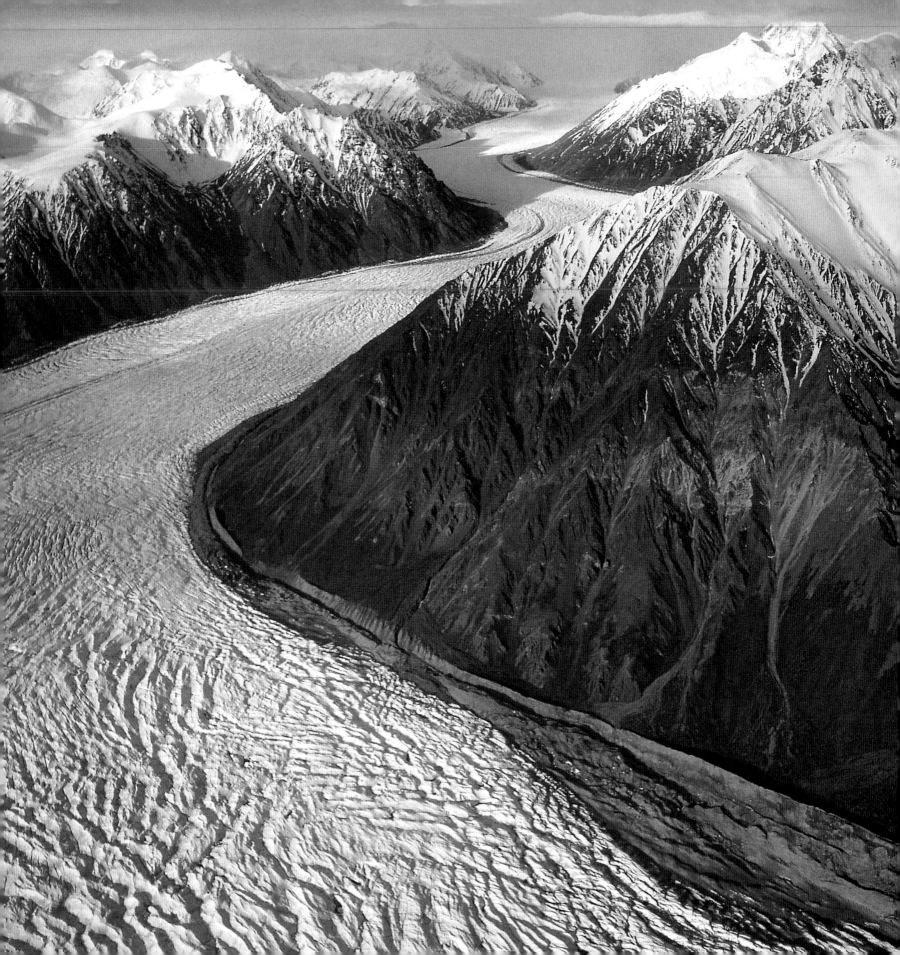

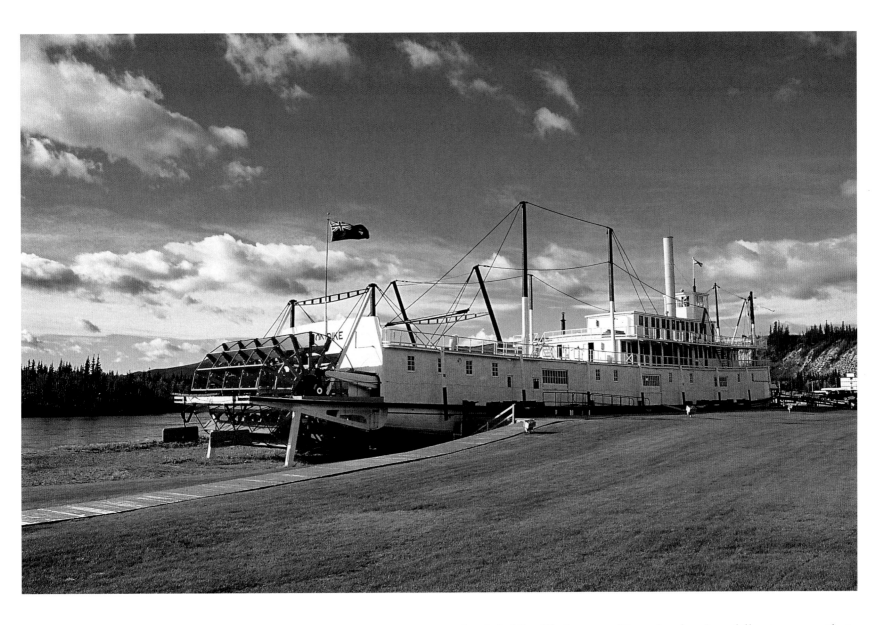

The S.S. *Klondike* is one of hundreds of paddlesteamers that once carried freight from Whitehorse to Dawson. A pilot ran this ship aground in 1955. Now a national historic site, it is a reminder of a lost era of prospectors and adventure seekers.

In the Icefield Ranges of the Yukon's St. Elias Mountains, some of the glaciers are more than a kilometre deep.

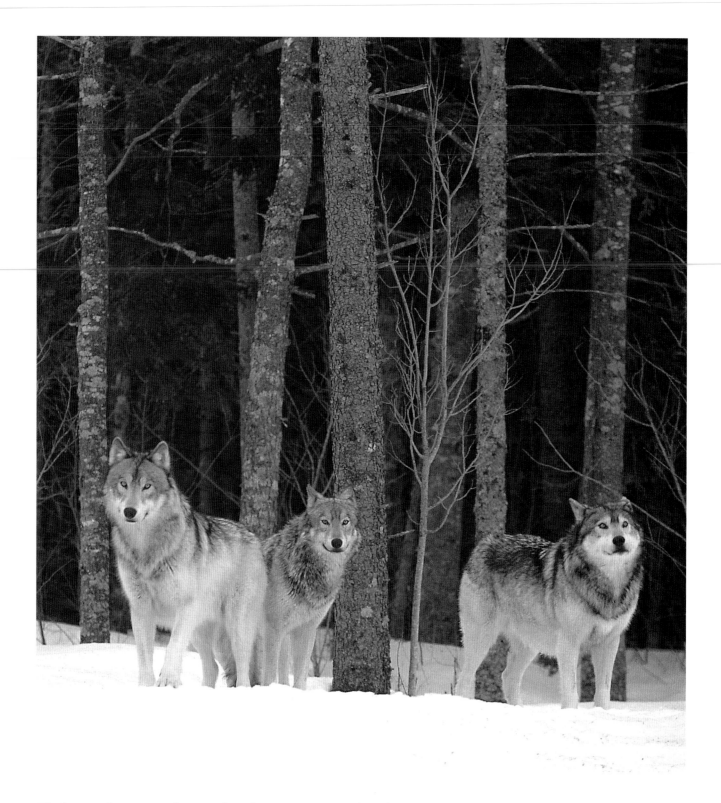

Timber wolves travel in packs of up to 20 animals. They are seldom seen, but their spine-tingling howls carry for more than six kilometres and can often be heard before a hunt.

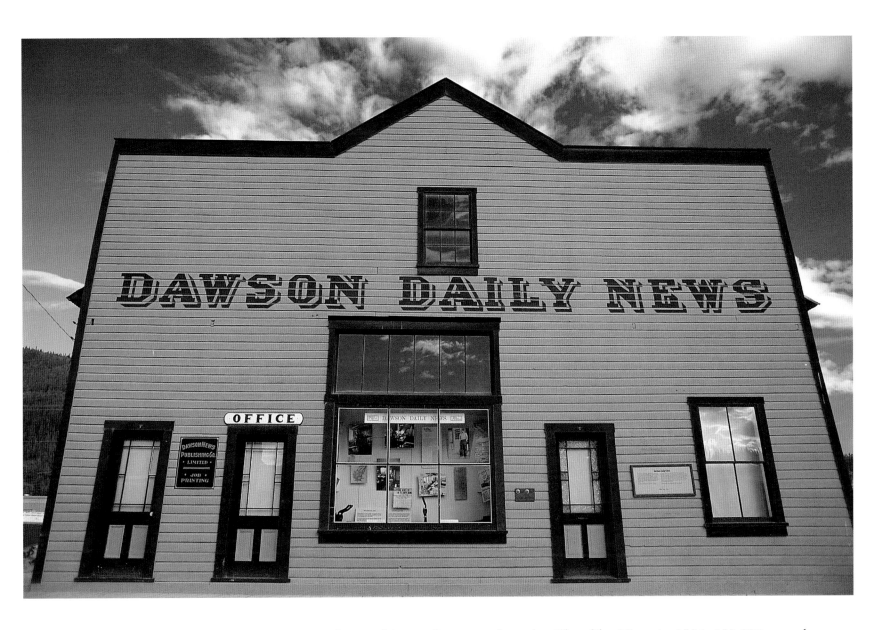

When gold was discovered on the Klondike River in 1896, 100,000 people swarmed into the Yukon, and Dawson City boomed. By the turn of the century the rush was over. The city is now a national historic site.

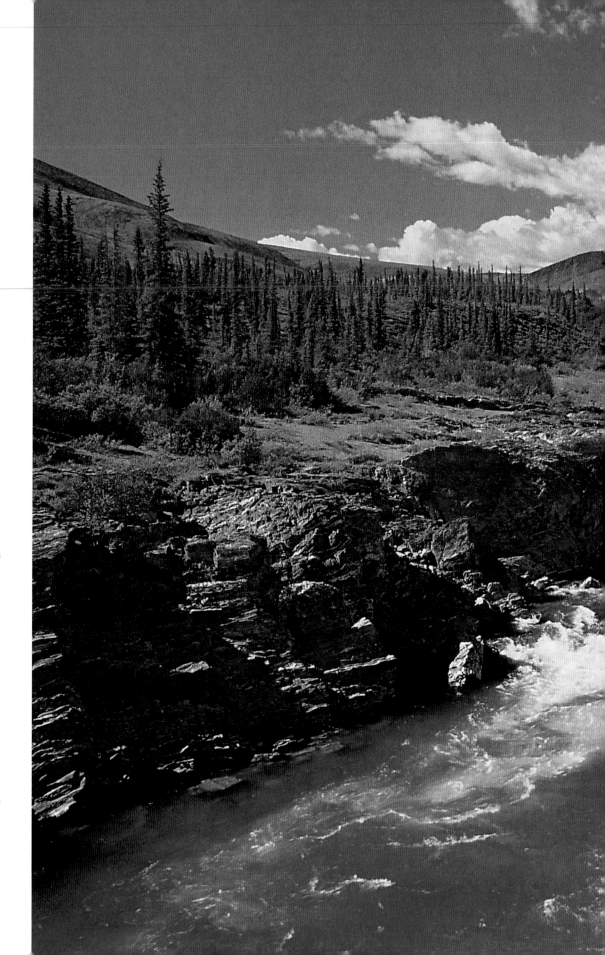

The icy Firth River rushes through Ivvavik National Park in the northern Yukon. *Ivvavik* means "nursery." The park is a birthing ground for thousands of caribou each spring when the world's largest caribou herd migrates to the area to calve.

<small>OVERLEAF —</small>
First Nations peoples have hunted and fished on Banks Island, Northwest Territories, for more than 3,000 years. An agreement with the government allows them to continue to use the area's resources now that Aulavik National Park protects the land.

88

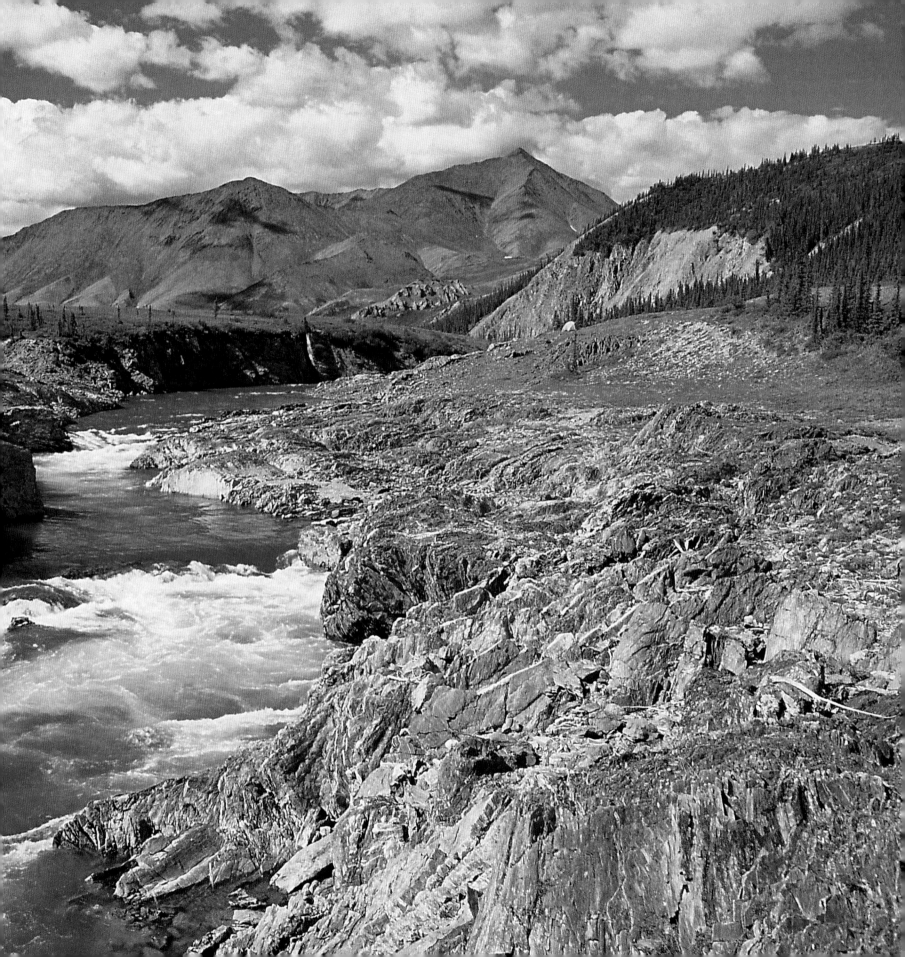

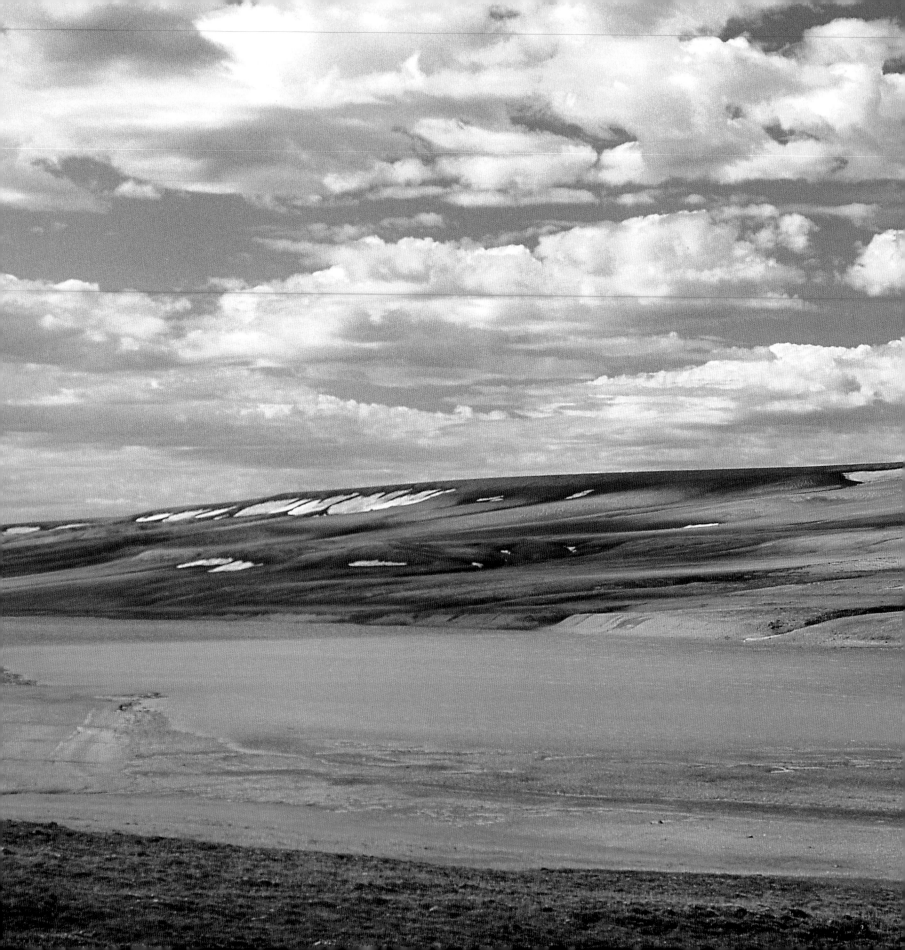

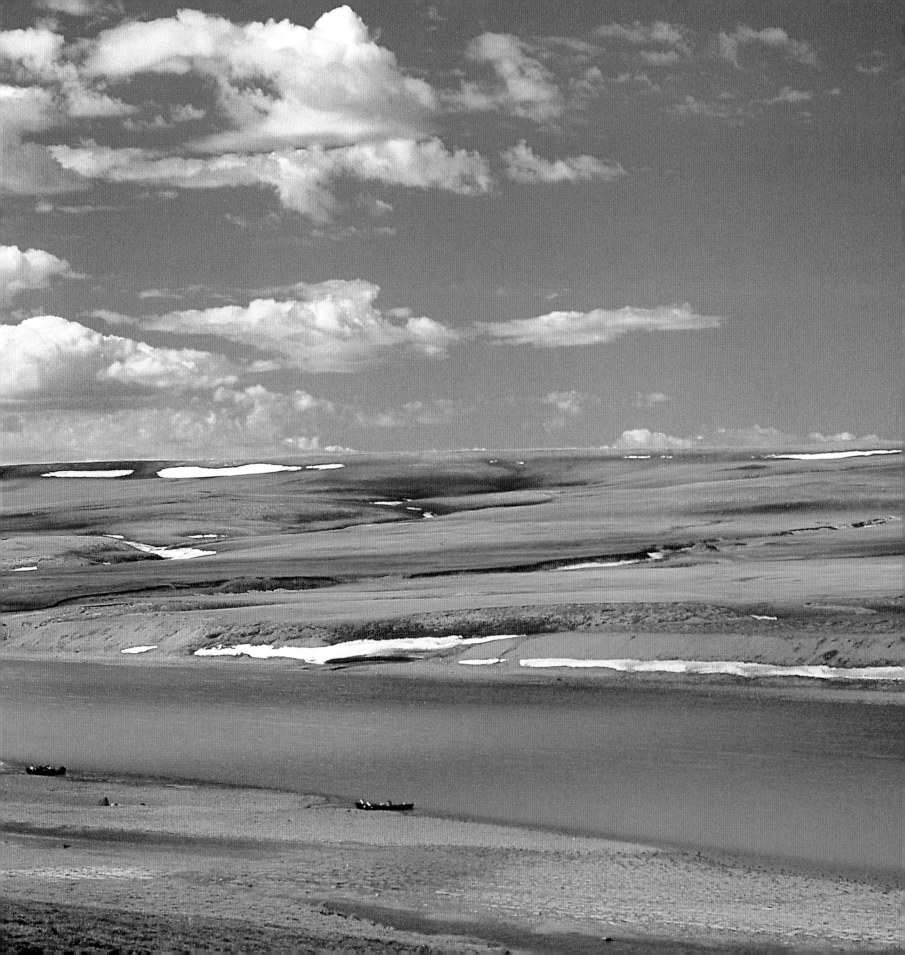

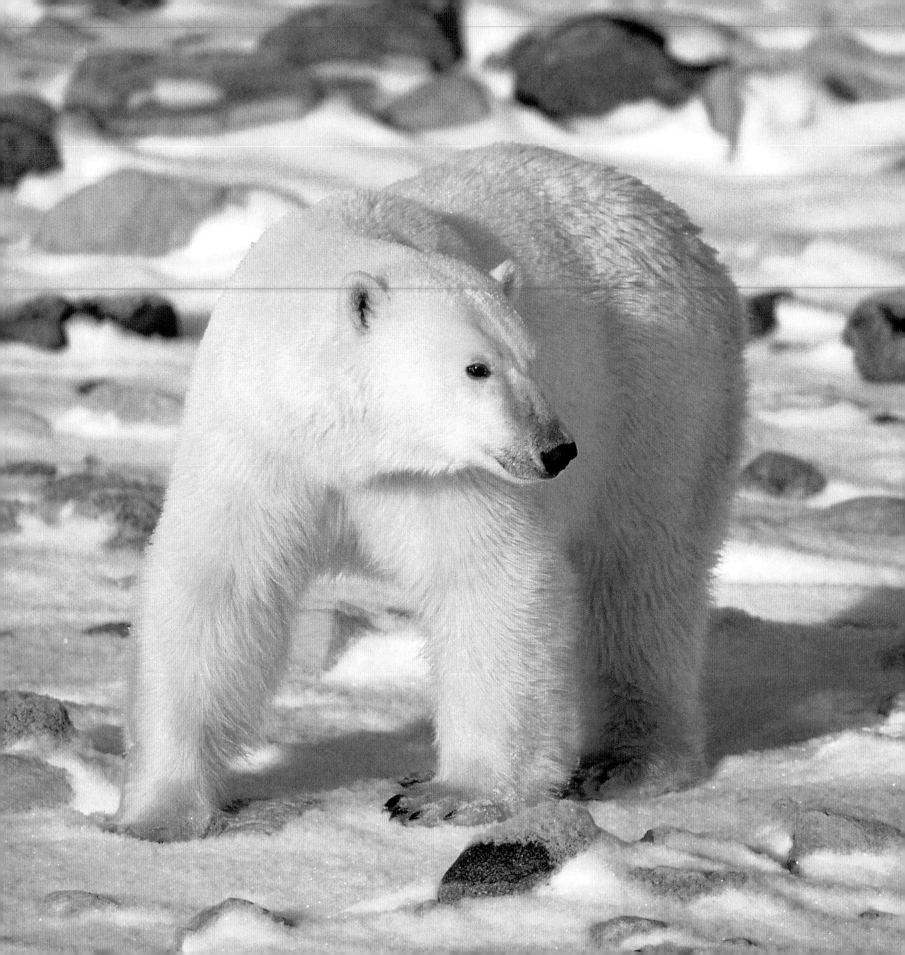

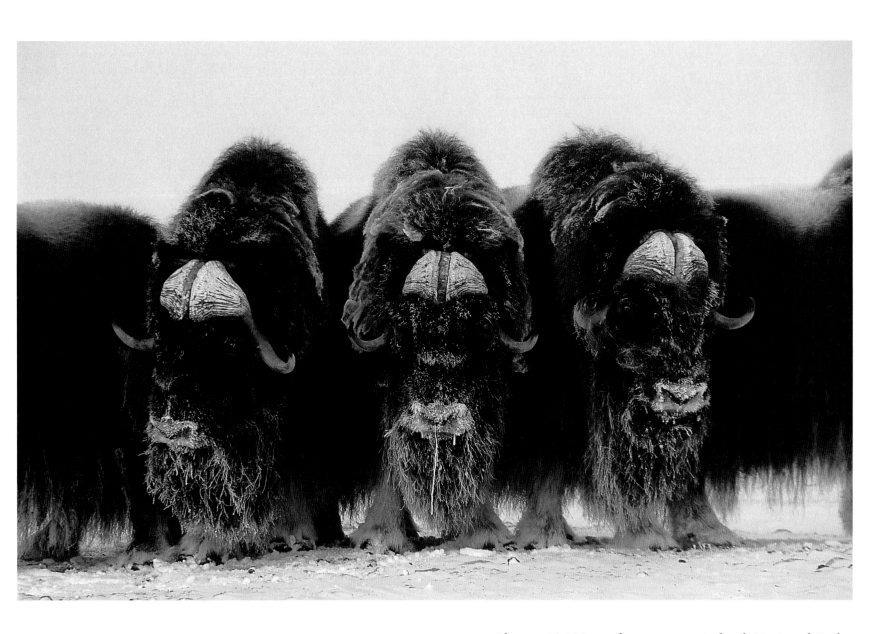

Almost 40,000 muskoxen roam Aulavik National Park. The muskox is well adapted to its chilly habitat. Its hooves are specially designed for stability on icy surfaces and its low stature and heavy fur help it endure the wind.

The polar bear is considered North America's largest land-based carnivore, though it spends much of its time on the ice. Each winter, the bears roam far from land in search of seals.

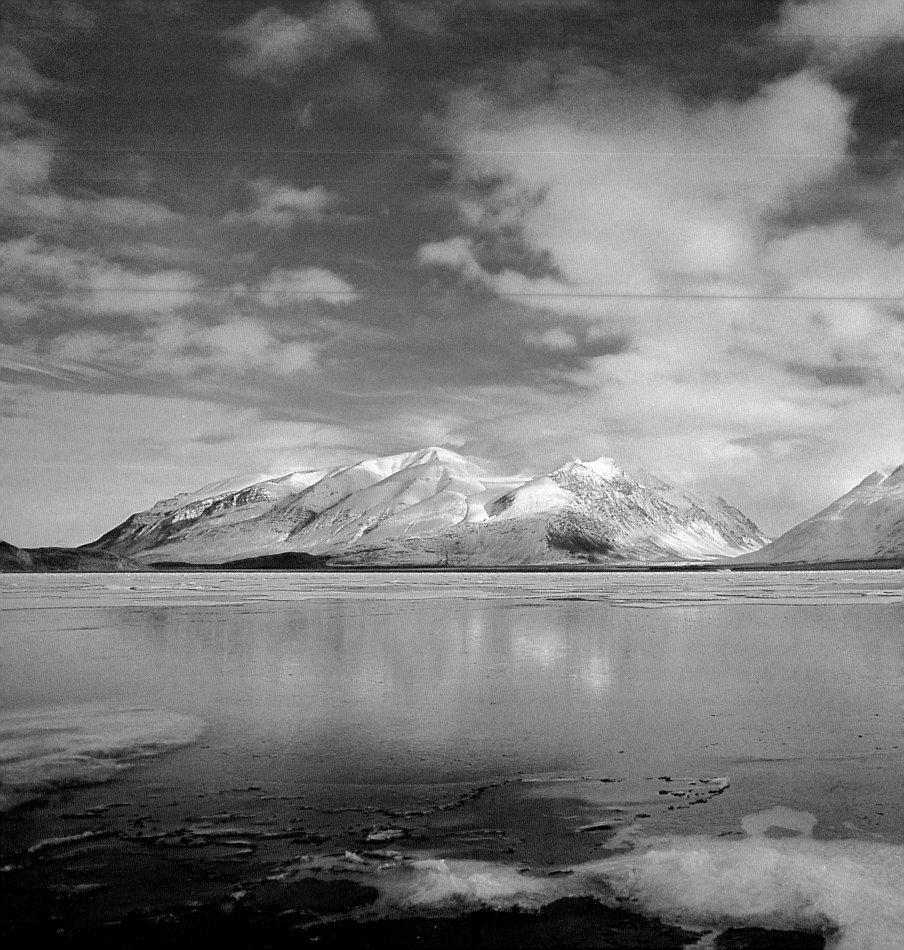

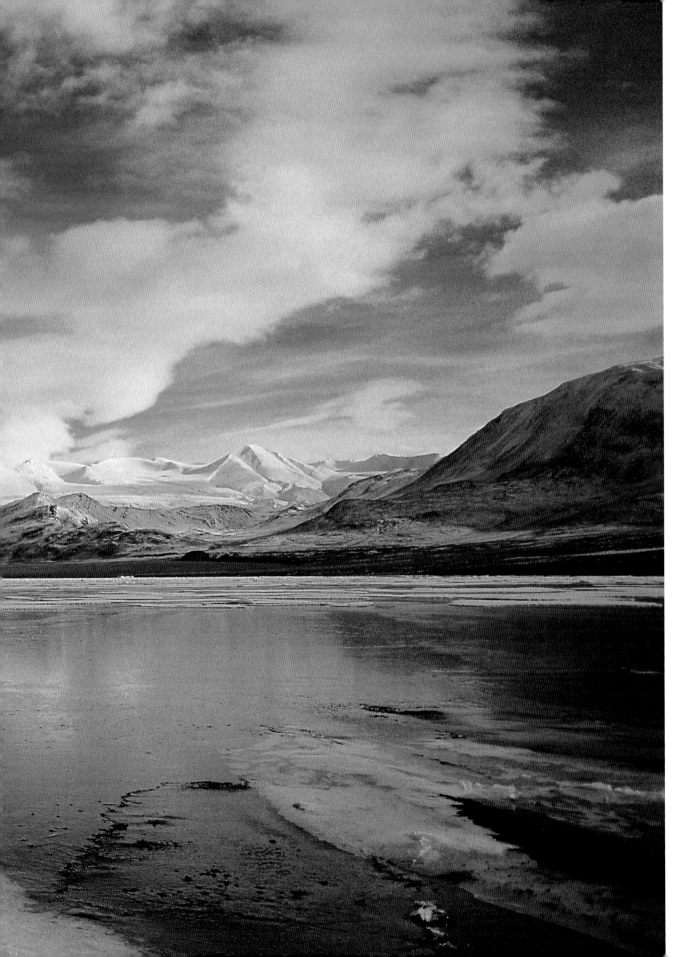

Ellesmere Island National Park in the Northwest Territories stretches for 37,775 square kilometres, more than six times the area of Prince Edward Island. Glaciers have carved the island into deep valleys and fiords, such as Tanquary Fiord, shown here.